FRIDA KAHLO
DIEGO RIVERA AND MEXICAN MODERNISM

FRIDA KAHLO
DIEGO RIVERA AND MEXICAN MODERNISM

THE JACQUES AND NATASHA GELMAN COLLECTION

Edited by
ANTHONY WHITE

■ national gallery of **australia**

First published in Australia in 2001
by the Publications Department of the National Gallery
of Australia, Parkes Place, Canberra ACT 2601

Designer Kirsty Morrison
Editor Jane Arms
Printer National Capital Printing
Canberra, ACT

Cataloguing-in-Publication-data

Frida Kahlo, Diego Rivera and Mexican Modernism:
the Jacques and Natasha Gelman collection.

Includes index.
ISBN 0 642 54153 1.

1. Kahlo, Frida, 1907-1954 - Exhibitions.
2. Rivera, Diego, 1886-1957 - Exhibitions.
3. Gelman, Jacques - Art collections - Exhibitions.
4. Gelman, Natasha - Art collections - Exhibitions.
5. Painting, Mexican - Exhibitions.
6. Painting, Modern - 20th century - Mexico - Exhibitions.
7. Painting - Private collections - Mexico - Exhibitions.
I. White, Anthony, 1964- . II. National Gallery of Australia.

759.972

Distributed in Australia by:
Thames & Hudson
11 Central Boulevard Business Park, Port Melbourne,
Victoria 3207

Distributed in the United Kingdom by:
Thames & Hudson
30–34 Bloomsbury Street, London WC1B 3QP

Distributed in the United States of America by:
University of Washington Press
1326 Fifth Avenue, Ste. 555, Seattle, WA 98101-2604

CONACULTA • INBA
Sari Burmudez, President, Conaculta
Ignacio Toscano, Director, INBA

(cover) **Frida Kahlo** *Self-portrait with braid* 1941

CONTENTS

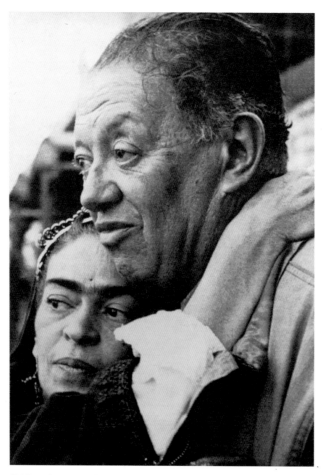

Frida and Diego at the Blue House 1954, Coyaocán, Mexico City
Photographer unknown © Conaculta/INBA

DIRECTOR'S FOREWORD

The self-portraits of Mexican artist Frida Kahlo are renowned for their dream-like quality and emotional intensity. A passionate woman endowed with an indomitable spirit, Kahlo overcame injury and personal hardship to become one of the world's most important female artists. Celebrated by the surrealists in her own lifetime, she has attained cult-like status both for her extraordinary art and her tempestuous love-life with her husband, Diego Rivera, Mexico's most prominent modern painter.

An outstanding selection of paintings by Kahlo and Rivera forms the centrepiece of the National Gallery of Australia's exhibition *Frida Kahlo, Diego Rivera and Mexican Modernism: the Jacques and Natasha Gelman collection.* Jacques Gelman, the Russian émigré film producer, and his wife, Natasha, built up their collection over many years of acquaintance and collaboration with Mexico's greatest creative artists. It is now widely regarded as the most significant private holding of twentieth century Mexican art.

Australian artists have long been aware of Diego Rivera, whose monumental mural paintings have inspired public art projects in this country, and gallery visitors in Australia were introduced to the work of Frida Kahlo through the 1990 exhibition, *The Art of Frida Kahlo,* at the Art Gallery of South Australia, Adelaide, and the Art Gallery of Western Australia, Perth. The exhibition on view at the National Gallery of Australia is the first opportunity for audiences to view the work of Frida Kahlo and Diego Rivera in the broader context of Mexican art, and to get a sense of the extraordinary vitality of cultural and artistic life in Mexico during the last century.

We are grateful for the assistance given by His Excellency, Mr Raphael Steger, Ambassador for Mexico, and by Dr Peter Farrell, Member of the Gallery Council and Foundation Board, who has sponsored the exhibition.

Brian Kennedy
Director
National Gallery of Australia

CURATOR'S PREFACE

Natasha Gelman died peacefully in her house in Cuernavaca on 4 May 1998 where, on that morning, as on every morning, she would have seen the peak of Popocatépetl from her bedroom window and faced, on the wall in front of her, a selection of self-portraits by Frida Kahlo.

During the fifteen years of my life in Mexico, my friendship with Natasha and her husband, Jacques, was a determining force in my cultural transition. After Jacques's death in 1986, Natasha and I increasingly shared time together, as I lived only an hour away in Mexico City. During my last visit, the weekend before she died, we went for lunch at her favourite restaurant, a converted seventeenth century manor house whose façade hides a tropical paradise with luscious gardens and wandering troops of white peacocks and yellow-tufted herons. Natasha asked for her usual table adjacent to the entrance where she could succinctly analyse and comment on the manner and character of clients entering and leaving. Her perceptiveness and direct observation pretty much sums up the way the Gelmans collected: without hesitation and without regard for the opinions of others – and always on target.

Natasha and Jacques Gelman acquired the canvases of Frida Kahlo and her husband, Diego Rivera, when there were only a handful of collectors in Mexico. And when the Gelmans became enthusiastic about an artist's work, they reinforced their convictions (as well as the artist's financial well-being) by buying in-depth the work of those so favoured. It just so happened that these artists came to be the most famous of their generation.

Natasha's great beauty was documented by the portraits her adoring husband commissioned from these same artists. One could fill a whole gallery just with them. Her last portrait, painted by the Spanish artist Rafael Cidoncha, demonstrates, half a century later, that she had not lost any of her brilliance, charm or vitality.

Natasha Gelman had a very clear idea of what was needed to complete and strengthen the collection that was housed in Mexico and New York on Jacques's death. She used her *connaissance* to add those works she felt were needed to complete the collection of the School of Paris painting and sculpture, which went to the Metropolitan Museum of Art on her death, and concentrated an equal amount of energy in keeping her Mexican collection up to date. This collection was placed throughout the rooms of her house in Cuernavaca.

One can take, for example, the late addition to the collection of an important oil by Francisco Toledo and the work of even more contemporary artists such as Adolfo Riestra, Sergio Hernández, Elena Climent and Paula Santiago.

This collection is still a work in progress, as it was for Natasha and Jacques Gelman during their lifetimes. In the year since her death, ten new works by contemporary and modern Mexican painters have been added, and the collection will continue to grow as both Jacques and Natasha would have wished, encouraging and supporting the Mexican artists of succeeding generations.

Robert R. Littman
Exhibition Curator

FRIDA AND DIEGO

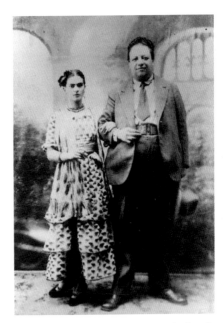

Ernesto Reyes *Frida and Diego on the day of their wedding, at the Reyes Studio in Coyoacán.* 21 August 1929, Mexico City
© Conaculta/INBA

While Rivera was painting massive murals depicting the heroic struggle of Mexican society to forge its own future, Kahlo was staring into a mirror, descending into the depths of her own being.

Rivera's mission was, in his own words, to 'reproduce the pure basic images of my land. I wanted my painting to reflect the social life of Mexico as I saw it, and through my vision of the truth to show the masses the outline of the future'. By contrast, Kahlo singlemindedly explored the female condition in a series of self-portraits that revealed the tragedy of her medical history and affirmed her Mexican identity. She was also, as Rivera said, 'the first woman in the history of art to treat, with absolute and uncompromising honesty, one might even say with impassive cruelty, those general and specific themes which exclusively affect women'.

Born in Coyoacán, Mexico, on 6 July 1907, Frida Kahlo was involved in a road accident at the age of eighteen that would affect the rest of her life. The bus she was travelling on was hit by a tram and she was impaled on a piece of metal – 'the arms of the seat went through me like a sword into a bull,' she recalled. Kahlo was plucked barely alive from the wreckage and rushed to hospital.

With her sister at her bedside and her family grief-stricken, Kahlo lay on her back in a plaster cast, her spinal column broken in three places, and with a fractured pelvis and numerous broken bones. Kahlo's injuries left her unable to have children and were the cause of grave ill health throughout her life.

Bedridden for some months, Kahlo abandoned plans of becoming a doctor – her intention since childhood – and began painting: 'My mother asked a carpenter to make me an easel, if that's what you call the special apparatus which could be fixed on to my bed, because the plaster cast didn't allow me to sit up. And so I started on my first picture …' It was three years after her accident that she met Diego Rivera.

Diego Rivera was born in Guanajuato on 8 December 1886 and studied at the Academy of San Carlos before travelling to Spain. He spent fourteen years in Europe,

where he mixed with the cubists (whose influence is evident in the 1915 painting *The last hour*) and studied western painting, attending in particular to Puvis de Chavannes and the symbolists.

In 1921, in the wake of the Mexican revolution, he returned home and became the central figure in the mural movement. Turning his back on early experimental works such as *The last hour*, Rivera produced an epic series of murals during the 1920s and 1930s – a period which is generally considered the apex of his career.

An ardent communist, Rivera travelled to the Soviet Union in 1927. During the following year, while Rivera was painting murals in the Ministry of Public Education, an admiring young woman seeking the elder artist's opinion of her work approached him. Kahlo was twenty-one at the time and Rivera forty-one. She became his third wife on 21 August 1929.

On their first meeting, Rivera immediately recognised the power of Kahlo's paintings: 'They communicated a vital sensuality, complemented by a merciless yet sensitive power of observation. It was obvious to me that this girl was an authentic artist,' he said.

As well as sharing political convictions – both were members of the Communist Party – Kahlo and Rivera had many artistic interests in common. Both were inspired by the primitivism of Rousseau and Gauguin and, most importantly, by Mexican folk art and pre-Hispanic culture.

Key figures in the Mexican cultural renaissance of the 1930s, Kahlo and Rivera were acutely aware of the significance of their historical moment. Although adopting some of the contemporary modernist art conventions, both were concerned with pictorialising such enduring themes as birth and death, fertility and barrenness. Although their individual styles were radically different, both were captivated by painting's potential to explore the human condition.

During the 1930s, the couple travelled the world, spending four years in the United States, where Rivera worked on murals in San Francisco, Detroit and New York. During this time Kahlo had to have her first pregnancy

terminated as a result of a 'pelvic malformation'. A devastating series of miscarriages affected Kahlo's health, which was at best precarious and, following an operation in 1934, she had several toes amputated. Her *Self-portrait with necklace*, painted in the previous year, is an oasis of calm during what was a harrowing time in her life.

Serious strains were emerging in the couple's marriage, with Rivera having embarked upon an affair with Frida's younger sister, Cristina. Kahlo wrote to her doctor: 'It has left me in a state of such unhappiness and discouragement that I do not know what I am going to do.'

By the following year, Kahlo had moved into an apartment on her own and regained her composure sufficiently to embark on an affair with the sculptor Isamu Noguchi. Kahlo and Rivera later resurrected their marriage, and Kahlo forgave her sister, who subsequently became, with her two sons, an integral part of the unorthodox Rivera–Kahlo family. Rivera's *Landscape with cactus* (1931) is a surreal depiction of sexual relations, but can also be read as a visual metaphor of the artist's complex family life.

In 1938 Kahlo and Rivera travelled to Michoacán with the exiled Russian Leon Trotsky (with whom Kahlo, famously, had an affair) and the leader of the French surrealists, André Breton, who immediately claimed Kahlo as a 'surrealist' despite her claiming to have no knowledge of the movement. Breton wrote of her work: 'The power of inspiration here is nourished by the strange ecstasies of puberty and the mysteries of generation … she displays them proudly with a mixture of candour and insolence.' He believed that, more than that of any other artist, Kahlo's art was quintessentially Mexican. 'The art of Frida Kahlo,' he concluded, 'is a ribbon around a bomb.'

It was rare for Kahlo's work to be given this degree of recognition at a time when Rivera's art, at least in the public mind, was considered indisputably the greatest of any living Mexican. (Tellingly, Kahlo's first solo exhibition in Mexico wasn't held until 1953 – the year before her death.)

Divorced in 1939, Kahlo and Rivera remarried the following year, having reached an arrangement, at Kahlo's

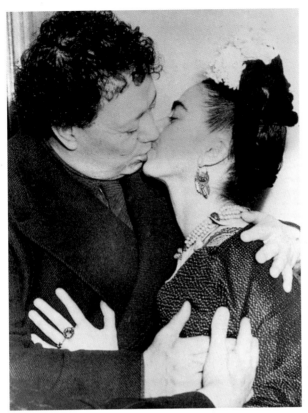

Nickolas Muray *Frida and Diego in San Angel*
1940, San Angel, Mexico City © Conaculta/INBA

behest, to share living expenses but cease sexual relations. Although this arrangement did little to alleviate the jealousy and torment Kahlo felt, the marriage lasted – despite numerous infidelities from both parties – until her death fifteen years later.

In 1943 Kahlo's work was exhibited in group shows in Mexico, Philadelphia and New York. Her paintings of that year attest to her maturity and growing eloquence as a painter. *Diego on my mind* and *Self-portrait with monkeys* are tough-minded revisions of the passive female subjects of western art history. Kahlo portrays herself as the master of her environment, both subject and object of the painting – the centre of her own universe. Yet the paintings have their dark side: anxiety and vulnerability persist. Although Kahlo's companions in *Self-portrait with monkeys* are traditional symbols of fertility and maternal protection, the painting can also be read as a study in childlessness and longing. *Diego on my mind* is a remarkable exploration of both entrapment and fertility, of devotion and its dark

cousin, obsession. Kahlo's paintings refer to her life incessantly, but it is their capacity to reach beyond their immediate circumstances that gives them power – a quality Rivera recognised in a 1943 essay:

Instead of miracles, the theme of her painting is the permanent miracle – life. Life that is always in flux, always changing and always the same in its movement through the veins and through the universe. A single life that contains the elements of all life. And if one tries to grasp its basis, one encounters abysmal depths, vertiginous heights, and an endlessly branching web that extends through the centuries, full of the light and shadows of life.

Kahlo's *Diego on my mind* resonates with the symbol of the 'branching web', suggested here by Rivera, only we find that Kahlo has placed the husband/painter spider-like at the centre of the web. She often painted Rivera, either in symbolic settings or in a comparatively conventional manner, as is the case with the earlier *Portrait of Diego Rivera* (1937).

In 1943 Rivera produced some of his most sumptuous reveries, among them such lavishly constructed works as *Sunflowers, Calla lily vendor* and *Portrait of Mrs Natasha Gelman* (whom Kahlo also painted that year). These works were produced during a hiatus in the midst of what was another busy decade of mural commissions for the prolific and much celebrated Rivera.

The confidence and vitality of Kahlo's paintings during the 1940s contrasted with her worsening health, depression and weight loss. By the end of that decade she was desperately unwell and undergoing spinal surgery. In the midst of these calamitous circumstances, she painted *The love embrace of the universe, the earth (Mexico), Diego, me and Señor Xolotl* (1949). Here she imagines herself as the mother figure in a Pietà-like composition, cradling Diego. The two figures are in turn embraced by the arms of the earth and, at the foot of the painting, the arms of the universe. This painting explores Kahlo's relationship with Rivera in terms of archetypal oppositions: night and day, sun and moon, conscious and unconscious, male and female, yin and yang.

During her final years, Kahlo – confined to a wheelchair but still painting vigorously – renewed her commitment to the communist movement: 'I must fight with all my strength so that the few positive things that my health allows me to do will help the revolution – the only real reason to live.'

Surprisingly, Mexico's great painter of the inner life reiterated her commitment to the social movement long associated with her partner, Rivera. The paintings, however, maintained their intensity and inner focus.

Of the health problems for which she was often heavily medicated, Kahlo wrote:

I have been sick for a year, from 1950 to 1951. Seven operations on my spinal column. Dr Farill saved me. He gave me back my joy in living. I am still in a wheelchair and I don't know if I will walk again soon. I have on this cast … I feel only weariness and, of course, a lot of times, desperation. A desperation that no words can describe. Nevertheless I want to live. I have started to paint …

For her exhibition at the Galería de Arte Contemporáneo in April 1953, Kahlo's bed was carried into the gallery so that the artist could be in attendance. In the midst of this gloomy scenario, Rivera observed:

It is not tragedy that rules Frida's work … The darkness of her pain is just a velvet background for the marvellous light of her physical strength, her delicate sensibility, her bright intelligence, and her invincible strength as she struggles to live and show her fellow humans how to resist hostile forces and come out triumphant …

That same year, gangrene developed in Kahlo's right foot and her leg was amputated below the knee. The psychological and physical trauma of this surpassed any of her earlier sufferings. She wrote:

It's been like centuries of torture and at moments I almost lost my mind. I keep wanting to commit suicide. Diego is the one that holds me back, for I am so vain that I believe he needs me. He has told me so and I believe it …

Her last public appearance was in July 1954. Wheelchair-bound and weak from her confinement to bed, Kahlo was taken by Rivera and friends to a rally protesting against the United States' intervention in Guatemala. Her appearance on this occasion was celebrated by Raquel Tibol:

She is a bundle of pain, aware of her premature ageing, yet she came out to express her disagreement with imperialism and its servants, instead of staying home to cry for her personal misfortunes.

Only days later, on 13 July, Frida Kahlo contracted pneumonia and died, aged forty-seven. Although a 'pulmonary embolism' was the official cause of death, suicide was not discounted as a possibility. Rivera was, according to friends, like a 'soul cut in two … he became an old man in a few hours, pale and ugly'. Rivera's own health deteriorated, and the following year he underwent medical treatment in the Soviet Union. He died on 24 November 1957. His wishes that his ashes be mingled with those of Kahlo were ignored, and he was buried in the National Rotunda of Illustrious Men.

Although Kahlo's work was overshadowed by her husband's during her lifetime, Frida Kahlo's reputation has subsequently grown to eclipse Rivera's. If their art represents different poles of the Mexican psyche, it must be acknowledged that the two artists were integral to one another, responding to and nurturing each other's work. Kahlo described Rivera as 'an architect in his paintings, in his thinking process, and in his passionate desire to build a functional, solid and harmonious society … He fights at every moment to overcome mankind's fear and stupidity'. In turn, Rivera celebrated Kahlo's commitment and virtuosity, describing her as 'the only example in the history of art of an artist who tore open her chest and heart to reveal the biological truth of her feelings'.

Gregory O'Brien

'PEOPLE ARE VYING FOR SHREDS OF HER GARMENTS'

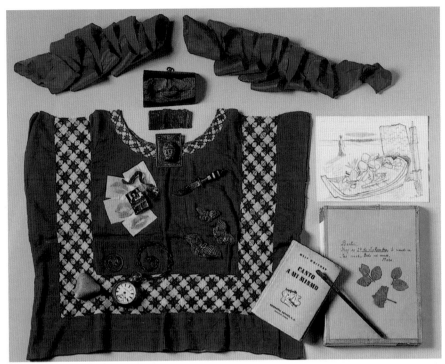

Frida Kahlo *Box with an assemblage of objects* from Sotheby's, *Latin American Art,* catalogue, New York, November 2000

In November 2000, a painting by Frida Kahlo five centimetres high – the size of a small egg – sold at a Sotheby's auction in New York for over $400,000. The extraordinary price this miniature piece attracted followed a 1999 auction record of over $10 million for a full-size Kahlo painting. At the same Sotheby's sale, a box of Kahlo memorabilia, including letter openers, ribbons, photographs and dried flowers, went for $100,000. As the New York dealer and Latin American art expert Mary Anne Martin has observed of the mania for all things Frida Kahlo: 'People are vying for shreds of her garments.'[1] Kahlo has become the exemplary modern cult figure, in the tradition of Christian saints and teenage pop stars.

'Fridamania' is not new. Little known and misunderstood in her lifetime, during the 1970s Kahlo's powerfully autobiographical paintings began to attract serious attention in the art world and in scholarly circles. Since then her legacy has grown into a multi-million dollar industry that crosses national and cultural boundaries.

When, in 1991, the Metropolitan Museum of Art in New York used a Kahlo self-portrait to advertise their exhibition *Mexico: Splendour of thirty centuries*, interest in the artist reached fanatical proportions, and the usual exhibition spin-off products, including postcards, posters and T-shirts, were complemented by a boom in Frida-inspired cosmetics, jewellery and cookbooks.

In more recent times, the entertainment press has been full of the competition between two rival American films vying to tell the story of Kahlo's life. Francis Ford Coppola's project, *The Two Fridas*, which took its name from a famous Kahlo painting, lost out to the Miramax production called *Frida*, starring Mexican actress Salma Hayek in the title role. A recent biographical novel of the same title by Barbara Mujica tells the Frida story through the eyes of her adoring yet intensely jealous younger sister, Cristina. In 1990 a Frida Kahlo bar opened in Melbourne which featured artificially aged walls on which images of Kahlo were painted. Patrons could sip margaritas sitting

on Mexican-style upholsteries under the intense gaze of 'antiqued' versions of the artist's famous self-portraits. Most recently, on the Internet, countless web sites dedicated to the artist's life and work have emerged, including one founding a religion called 'Kahloism' which, as its author explains in breathless tones, 'worships Frida Kahlo as the one and true God.'[2]

To what can we attribute this cult-like worship of an artist who, during her own lifetime, was considered little more than a beguiling appendage to her husband, the famous Mexican painter Diego Rivera? The fascination that Frida Kahlo holds in popular imagination seems to result from the way her life story resonates with the experiences of millions of women and on the extraordinary qualities of the art works themselves, without which she would be an entirely forgotten figure.

Pain is something we all feel, some of us more than others. Whether it is merely unpleasant or blindingly intense, it reminds us that we are neither immaterial spirits nor pure consciousness but flesh, rooted in the physical world. Each twinge and cramp tells us that our destiny is to wither and die – that is our fate. Counterposing this is the irresistible idea that we can somehow transcend that mortality, whether through sheer endurance or strength of character, rising above what fate has dealt us.

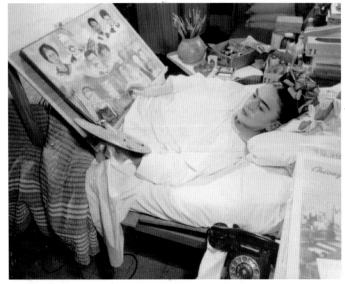

Juan Guzman *Frida working in bed* 1952 Mexico City
© Cenidiap / INBA / Mexico

Physical and psychological suffering lay at the heart of Frida Kahlo's genius. Afflicted with polio as a child, her right leg was crippled from an early age. In a terrible bus and tram collision in 1925 Kahlo was impaled on a metal handrail that penetrated her spinal column and pelvis and exited through her vagina. After the accident, she underwent more than thirty operations in an attempt to correct its effects, among which were limited circulation in her right leg, a misshapen spine and pelvis, and numerous failed pregnancies. Late in life her right foot became gangrenous and had to be amputated.

In the Gelman collection, it is the allegorical painting *The love embrace of the universe, the earth (Mexico) Diego, me and Señor Xolotl*, of 1949, which most clearly relates to Kahlo's history of injury and pain. The artist depicts herself with a gaping wound coursing through her body, culminating in a fountain of blood gushing from her left breast. The wound has a symbolic significance, marking her as a giver of life, but there are clear parallels in the image to her gory tram accident. Aside from this work there are few direct depictions of physical suffering in the Gelman collection of Kahlo's work, but an autobiography of personal tragedies seems to lurk behind even the most benign of her paintings. Her feelings of despair about being childless and in a troubled marriage to Diego Rivera, a notorious philanderer who had an affair with Kahlo's sister, seem to blaze within her steady gaze. As Kahlo said, 'I suffered two grave accidents in my life. One in which a streetcar knocked me down … The other accident is Diego.'[3] The viewer is drawn into complicity with her awful suffering through her catastrophic life-story. At the same time, by exposing her pain unflinchingly to the world through art, Kahlo comes across as a woman of indomitable spirit who triumphed over colossal odds – far more than just a survivor.

Margaret Lindauer has taken issue with the representation of Frida Kahlo in various biographies, claiming that the anguish of Kahlo's life story has been exaggerated, both by the artist herself and by her biographers.[4] Whatever the truth of the matter, one of the significant sources of Kahlo's recent celebrity has been a

narrative of suffering which feeds into a well-established, popular fascination with personal struggles with pain. One thinks immediately of the attention paid to the emotional upheavals of Diana, Princess of Wales and the monumental outpouring of grief after her death. Kahlo's significance for contemporary audiences is intimately connected to this kind of narrative – accidents, eating disorders, marital strife, troubled love affairs, miscarriages – which has become part of the larger 'Frida' phenomenon.

Although Kahlo drew extensively on the Mexican religious tradition of *retablo* paintings that describes divine interventions, her work also connects to a pervasive tradition in western art that depicts the tribulations of saints. For Christian audiences, these images have provided some of the most eloquent and moving visual expressions of physical pain. By withstanding suffering and death, such Christian figures are exemplary because the power of their belief enables them to transcend the strictures of the physical world. In one of the most well-known and frequently depicted Christian images, St Sebastian is shown trussed to a column and pierced by arrows that have sunk deeply into his flesh. As his gaze lifts heavenwards and he breathes a last sigh before his assumption and subsequent canonisation, we feel at once repulsed by the iniquity of his fate and inspired by his divine forbearance.[5] In the face of two extreme human experiences, abject suffering and spiritual transcendence, our own concerns and aspirations may seem small. For all that, we cannot help identifying with this noble young man struck down in his prime. Who among us has not suffered the 'slings and arrows of outrageous fortune'?[6]

For a male viewer, the image of St Sebastian readily exemplifies the capacity to identify emotionally with human suffering. The figure of Frida Kahlo, on the other hand, appeals especially to women, as the predominance of works by female authors in the literature on Kahlo attests. Kahlo's rising popularity in the 1970s was paralleled by the growth in feminism, which began to have a profound effect on art history in that decade. As Linda Nochlin observed in her famous 1971 essay, 'Why have there been no great women artists?' feminists in this period began to search for undervalued female artists, believing that women had been systematically excluded from the male-dominated canon of western art.[7] Frida Kahlo would become one of those found artists.

Kahlo appealed to feminists for a variety of reasons. She was a committed communist who believed in the overthrow of capitalist society. Her views endeared her to many women who, radicalised in their efforts to transform patriarchal society, found themselves in sympathy with left-wing ideologies. But more than that, although Kahlo's work was often about suffering and pain she never portrayed herself as a helpless victim. Her extravagant costumes, her uncompromising depiction of facial hair, in contravention of western notions of female beauty, and the prepossessing air of her posture and her steely gaze made her paintings irresistible to a new generation of female scholars and art lovers. Here was an inspired female artist who offered a clear alternative to the male objectification of women.

And released from the burden of bearing children she was liberated from the biological prescription for women in a patriarchal society. Kahlo seemed to literally clothe herself in this freedom, masquerading in traditional Mexican costume that both exaggerated and parodied female identity. It is no coincidence that Madonna, the contemporary pop singer who has made a career of flaunting conventions of feminine costume in an irreverent, even radical way, became one of the most well-known collectors of Kahlo's work in the early 1990s.

One does not have to be a martyr or a feminist, however, to find resonances with Kahlo's paintings. Although conditions for women have improved enormously in western countries in this century, some women still find themselves disadvantaged: unrecognised as mothers, poorly paid by comparison to their male peers, or locked into violent or unhappy marriages. In many ways, the story of Kahlo's life has echoes for many of these women. In particular, Rivera's fame overshadowed Kahlo's achivements as an artist for a long time. It was only after her death in 1954 that Kahlo's popularity soared and outstripped that of her husband.

This must seem like the ultimate vindication to generations of women whose talents and achievements have been downplayed when set against those of their husbands or lovers.

Another aspect of Kahlo's work uniquely addressed to women is the theme of childbirth that runs through so much of her painting. With our knowledge of her inability to bear children, we look at these self-portraits in which she is accompanied by dolls and animals – surrogate child figures – as poignant expressions of the frustrated desire to become a mother. As Kahlo said in 1953, she sublimated this frustration into her art: 'Painting rounded out my life for me. I lost three children before they were full term and there were other things that filled my life with horror. I substituted painting for all that.'[8] In spite of the release she found in her art, the viewer never feels let off the hook by Kahlo's paintings.

Even an apparently innocent image such as *Self-portrait with bed* of 1937 seems to unravel before our eyes as we contemplate the difficult situation in which Kahlo finds herself. In Mexico, motherhood is still regarded by many as women's main purpose in life. Late in life Kahlo accepted that she would never have children, but in her paintings it is not clear how reconciled she was to this fate. In *Self-portrait with bed* the stiff, wooden baby, with its 'kewpie doll' face, cannot be considered a comforting child surrogate; its lifeless body only exacerbates the perceived sense of emptiness. Kahlo sits squarely on the unfurnished bed smoking a cigarette – a classic symbol of female independence – and through her gaze invites the viewer to fathom her state of mind. Pride is here mixed in equal parts with vulnerability, and the remoteness of the image tells us that Kahlo was largely concerned to record accurately her physical and psychological situation in a way that would avoid pity. This painting seems to bear witness: *this is how it was*.

If Kahlo's work does not invite pity, her paintings are never cold, factual documents, but instead ask for identification and empathy. The genre of the self-portrait that dominates Kahlo's work is ideally suited to this end.

We can all understand portraits at some level, without any education or previous knowledge, and in self-portraiture we seem to be faced with a revelation of the unmediated truth of the soul. Just as divine figures do not become truly manifest in altarpieces, nothing of the sort really occurs in any portrait. But the pervasive sense we have of an identifiable human presence in portraiture means that Kahlo's paintings, given her other extraordinary gifts, were destined for a broad audience. That she often added unconventional elements from religious art or adopted the surrealist technique of imaginative association from time to time only confirmed this accessibility – religious art has a long history of speaking to an uneducated public, and Surrealism has, since its founding in the 1920s, become the *lingua franca* of that most democratic of arts, commercial advertising.

Ultimately, the reason for Kahlo's immense popularity rests on her extraordinary capacity to make us empathise with the conditions that she endured.

In inviting us to enter her world, no matter how extreme and distant from our own, Kahlo allows us to see that we – all of us – are saints in a way. In moments of inspiration, such as those granted us by her paintings, we recognise our fate – that circumstances are sometimes against us, that we are not long for this world. In spite of that knowledge, we also remain convinced that we are vast, immortal and special. Kahlo's pictures present this disturbing and magnificent truth with breathtaking clarity.

Anthony White

'A PACT OF ALLIANCE WITH THE REVOLUTION': ART AND POLITICS IN MODERN MEXICO

Diego Rivera, David Alfaro Siqueiros, José Clemente Orozco and Frida Kahlo painted while the first social revolution in the Americas, the Mexican revolution, was unfolding. They engaged with the revolution's radical goals – land reform for peasants, labour conquests for workers, the emancipation of indigenous people, and the struggle for greater independence from the United States.

THE 1910 MEXICAN REVOLUTION

Few people expected revolution to erupt in Mexico in 1910, a year in which Mexico's ageing dictator, Porfirio Díaz, was overseeing preparations for the centenary of Mexico's declaration of independence from Spain in 1810. But the Porfiriato was shattered by an unlikely coalition of revolutionaries whose actions plunged Mexico into a decade of violent military conflict. It did not take long to put an end to the rule of Diaz, who abandoned Mexico for exile in Europe in late 1910. But the military and then electoral victory of Francisco Madero, the first president of revolutionary Mexico, did not bring peace. For the revolutionaries could not agree on what kind of Mexico should emerge from the debris of the Díaz dictatorship.

The revolutionaries came from widely differing backgrounds. On the 'left' were peasant-based armies headed by people of modest means, like Emiliano Zapata from the southern state of Morelos (a figure much admired by the revolutionary muralists and painters, especially Rivera and Orozco) and the leader of the cowboys, miners and agricultural workers of northern Mexico, Francisco (Pancho) Villa. Their vision was of a Mexico in which the great haciendas or estates would be returned to peasant communities and farm workers.

On the 'right' stood a coalition of urban professionals and dissident landowners; Francisco Madero himself came from a wealthy land-owning family. Supporters of political democracy and a career open to talents, Madero and another landowner turned revolutionary, Venustiano Carranza (who dominated politics between 1915 and 1920), were reluctant revolutionaries, hostile to notions of radical land reform. By 1920, the more conservative revolutionaries of the 'right' had managed to defeat the Villa–Zapata coalition. Zapata was assassinated in 1919, and Pancho Villa was killed, almost certainly on government orders, four years later.

THE 1920s

The decade of the 1920s, dominated by a series of presidents from northern Mexico – Alvaro Obregón and Plutarco Elías Calles, was an era of consolidation.

The government fought stubbornly to curb military challenges to the central state, and both Calles and Obregón promoted reforms that strengthened the authority of the national state and its allies. Private property and foreign investment would be protected at the same time as land reform and support for trade unionism would build loyalty to the state among peasants and workers. Literacy campaigns and a bloody program to curb the cultural and political power of the Catholic Church and its rural allies were also key policies of the governments of the 1920s.

THE 1930s

Relations with the United States improved as Mexico moderated the harsher features of nationalist policies and made concessions to its powerful neighbour. But it was in the second half of the 1930s, during the presidency of Lázaro Cárdenas (1934–1940), that the Mexican revolution passed through its golden age. Cardenas massively increased the scope and pace of land reform and decreed the nationalisation of foreign oil companies in 1938.

THE ARTISTIC REVOLUTION

The Mexican revolution also developed a politics of culture. The *ancien régime* of Porfirio Díaz had shown contempt for mass culture. Its ideologues, the *cientificos* [scientists], had argued that the backward-ness of Mexico's indigenous people was an obstacle to economic and political development and called on Mexicans to adopt the cultural practices of Europe and the United States. In the 1920s, the painters and muralists of what came to be known as the Mexican Renaissance broke violently with the Porfirian legacy, the cultural cringe that proclaimed that everything foreign was good and everything Indian rotten and worthless.

President Obregón's Minister of Public Education, José Vasconcelos, made the artistic renaissance possible. He called on all of Mexico's intellectuals 'to sign a pact of alliance with the revolution'. Cultural nationalism was to be harnessed to the task of making better citizens, promoting a new *mexicanidad* [Mexicanness] and strengthening government control over the masses.

To further his project, Vasconcelos commissioned artists and intellectuals to illustrate cheap, mass-produced textbooks and editions of the classics for the general public. He also commissioned painters such as Rivera and Siqueiros to decorate the walls of important official buildings, the first being the National Preparatory School in Mexico City, where work began in 1921.

It was while working on his first mural at the school that Rivera first met the very young Frida Kahlo who would later become his lover and then wife.

Later in the 1920s, the government commissioned murals in the Ministry of Education and the Presidential Palace (beginning in 1929).

THE CULT OF MEXICO

Rivera and Orozco seized the opportunity to rediscover Mexico through the medium of popular art. Rivera, who had spent his formative years from 1911 to 1921 in Paris, Madrid and Rome, returned to Mexico in July 1921. Vasconcelos immediately sent him on a two-month journey to southern Mexico to the Tehuantepec Peninsula to re-establish contact with Mexican reality. The Tehuantepec region was famous for its tall elegant Indian women and no doubt Rivera was constantly reminded of this trip by the floor-length skirts and richly embroidered blouses worn by Kahlo.

Rivera and Siqueiros were linked by more than a passionate interest in re-discovering Mexico. Government propagandists they may have been, but Rivera and Orozco were also determined to commit their lives to 'the native humiliated masses' and to 'workers and *campesinos* [peasants] squeezed dry by the rich'. The quotations are from the manifesto of the syndicate of technical workers, painters and sculptors, which was drafted by Siqueiros in September 1923. One year later, the artist–worker members of the syndicate began to illustrate the pages of a new newspaper, with the provocative title *El Machete*, its slogan announcing, 'The Machete is used to cut cane, to open paths in the dark forests/decapitate snakes, crush all grass/ and humiliate the arrogance of the impious rich.' The following year *El Machete* became the official organ of the Mexican Communist Party on whose executive committee sat Rivera and Siqueiros.

In spite of their communist credentials, Rivera and Kahlo received commissions to work in the United States. These artists of the Mexican Renaissance were fascinated by the technology, machines and fantastic urbanisation of their northern neighbour. At the same time, waves of American liberals and leftists were making the pilgrimage south to observe at close hand the Mexican revolution's experiments in social and cultural change.

Barry Carr

JACQUES AND NATASHA

Mexico has held a powerful fascination for the western world since the Spanish occupation in the early sixteenth century. When Hernán Cortés and his soldiers arrived on the shores of the New World, their goal was to conquer Tenochtitlán, a city built on the swamps and islands around the site of modern-day Mexico City. The Aztec emperor Montezuma, impressed by the apparently magical powers of the Spaniards, treated the invader as if he were a god. Although the Spanish forces destroyed the ancient city and massacred its inhabitants, on entering the magnificent Aztec capital, Cortés and his soldiers had been wonderstruck. Here was a fabulous city that appeared to be floating on water, its walls covered in gold, the stuff of enchanted dreams.

Today Mexico is a thoroughly modern nation. Centuries of autocratic or military rule have been replaced by open democratic government and, in economic terms, it is the envy of Latin American countries, now the eighth-largest exporter in the world.

For all that, the history of twentieth century Mexico, with its epic political struggles and extraordinary cultural riches, still evokes the fascination that the country held for its earliest European explorers. Nowhere is this more evident than in the international response to Mexican modern art. Diego Rivera's colossal mural paintings, great sweeping narratives of Mexican history, were emulated throughout North America, Europe and Australia by generations of artists who believed that public art could educate and uplift people. Frida Kahlo's startling self-portraits, which penetrate the artist's inner life like no other paintings in the twentieth century, generated a similar response.

Jacques and Natasha Gelman, emigrés from Eastern Europe who made Mexico their home in the 1940s, were an important part of this international interest in the art and culture of their adopted country. Their extensive collection of Mexican modern art is a testament to the fascination of Mexico in the western mind.

Through their activities as art collectors in Mexico and their relationships with artists, Jacques and Natasha Gelman were intimately associated with the development of Mexican art from the 1940s. Jacques was so successful that he and his wife were able to fulfil their dream of collecting significant examples of European and Mexican art. When the Gelmans' collection of European art was donated to the Metropolitan Museum of Art in 1986, it was the most important single donation of twentieth century works received by that institution.[1] What remains of the Gelmans' collection is regarded as the most significant private holding of Mexican twentieth century art.

Their collection covers a broad range of artists, periods and styles. From the earliest cubist-inspired paintings by Diego Rivera, to the surreal images by Frida Kahlo and Leonora Carrington and the abstract works by Gunther Gerzso, each work reflects Jacques and Natasha's discerning but multifarious taste, and their commitment to the very best that Mexican art had to offer. Like all private collections, the work they bought reflects something of the Gelmans themselves. This is most clearly evident in the numerous portraits of both husband and wife. There are no less than six portraits of Natasha, including those by Rivera and Kahlo, and two portraits of Jacques. The theme of portraiture continues through the collection, forming a kind of visual *leitmotif*. It includes the stunning self-portraits by the Mexican muralists

Siqueiros and Orozco, and the numerous self-portraits by Kahlo and her portrait of Rivera.

Although Kahlo is renowned for bizarre images that recount the traumatic events in her life, including accidents, miscarriages and betrayal, Natasha Gelman opted to collect works in which the ferocity of Kahlo's self-exposure was tempered by the equally strong urge to make superb works of art. Natasha's eye was drawn to such works as *Self-portrait with monkeys*, where Kahlo's consummate skill as an artist manifested itself in a more constrained but no less poignant revelation of her intense feelings. Natasha's preference for work by women artists, of which the paintings of Frida Kahlo and María Izquierdo are only the most notable examples, also influenced the shape of the collection.

For all that the Gelman collection represents the individual tastes of Jacques and Natasha, it also documents a time of extraordinary creative power in the cultural history of Mexico that has come to be called 'Mexican Modernism'. This term, which is used in the title of the National Gallery of Australia's exhibition, encapsulates the innovative spirit with which Mexican artists responded to historical and cultural events in the revolutionary period of 1910–1920. These events engendered an impulse to create a truly Mexican art that would have its roots in indigenous culture and communicate to the people at the broadest level.

Riding the wave of enthusiasm for a genuinely national and democratic art was the formidable figure of Diego Rivera. Rivera was born 1886 in Guanajuato and moved with his parents to Mexico City. He was an exceptionally gifted painter and studied at Mexico's National School of Fine Arts. In 1909 he visited Europe, where he studied Italian fresco techniques and came into contact with modernist painting movements. Although not in Mexico during the period of revolution, he was inspired from afar by the events in his home country and returned in 1921 eager to put his international experience to the test in the new Mexico.

During the 1920s Rivera began painting the grand mural works that made him famous. He shared a belief with his colleagues that easel painting was a bourgeois art form that should be replaced by grand mural decorations telling the history of Mexico to large numbers of people. The 'Manifesto of the Union of Mexican Workers, Technicians, Painters and Sculptors', which was signed by Rivera in 1923, proclaimed:

We reject so-called salon painting and all the ultra-intellectual salon art of the aristocracy and exalt the manifestation of monumental art … the creators of beauty must turn their work into clear ideological propaganda for the people, and make art … something of beauty, education and purpose for everyone.[2]

In the enormous painting commissions of the 1920 and 1930s, Rivera realised this goal by synthesising various artistic tendencies, including modernist styles such as Cubism, with Italian Renaissance painting and Mexican popular art.

In the 1930s, Rivera settled with Kahlo in the United States, where he painted some of his most controversial commissions. His mural for the Rockefeller Center in New York was destroyed on the instruction of the Rockefeller family when the artist refused to remove a portrait of the communist leader, Vladimir Lenin. Rivera and Kahlo were both members of the Communist Party and, like many other Mexican artists of their time who were living in the wake of the revolution, they felt that their art should reflect their strongly held political beliefs.

Rivera's earlier work, such as the cubist masterpiece, *The last hour*, of 1915, painted while he was in Paris, shows the artist embracing that modernist style. Recognisable objects such as books, vases and a newspaper have been reduced to two-dimensional geometrical elements that appear to shift and scuttle on the picture plane. In his subsequent work, like other modernist painters in Europe, he moved to a more solid rendering of form, without the visual distortions seen in cubist painting.

The Gelman collection does not contain any mural paintings, but the *Calla lily vendor*, painted in 1943, borrows a theme from one of his frescoes at the Mexican Ministry of Public Education from the 1920s. The symmetrical composition, simplified forms and indigenous Mexican subjects evident in this painting are qualities that pervade his later work.

In another work, *Portrait of Mrs Natasha Gelman*, painted in 1943, Rivera paid a Hollywood-like tribute to feminine beauty. In this work, his approach was more indulgent, and he abandoned the severity of his signature style, emphasising Natasha's sinuous and elegant curves, which are mimicked by the extravagant bunches of lilies in the background.

Two other important mural painters who worked alongside Rivera were famous in their own right – David Alfaro Siqueiros (1896–1974) and José Clemente Orozco (1883–1949). Together they formed the Mexican Mural Movement, painting some of the most significant revolutionary public art of the twentieth century. Although all three artists were intent on communicating political and social ideals, the paintings of Orozco and Siqueiros are more vigorous and expressionist than those of Rivera. Siqueiros's work has an important connection with the National Gallery of Australia's collection. The American artist Jackson Pollock worked as an assistant to Siqueiros in New York during the 1930s. During that time Siqueiros experimented with many different painting techniques for his large-scale murals, including spray guns, airbrushes and industrial paints such as Duco. This gave Pollock ideas about increased scale and experimental painting methods such as those employed in the National Gallery of Australia's *Blue poles*.

Rivera's European artistic influences were Italian Renaissance frescos and cubist painting, but many Mexican artists who worked outside the mural painting movement had connections to the French surrealist movement. Frida Kahlo remains the best known artist

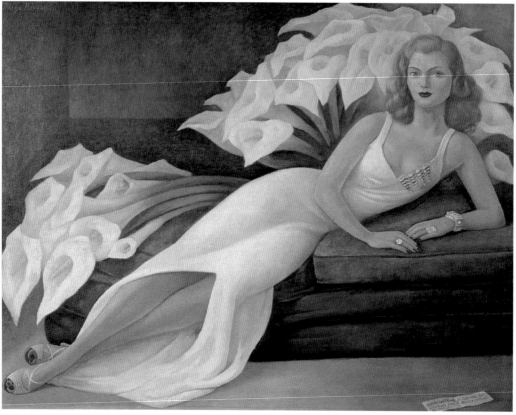

Diego Rivera Portrait of Mrs Natasha Gelman 1943

working in this mode, but another important figure featured in the Gelman collection is the English-born painter Leonora Carrington, who moved to Mexico in 1942. Born in 1917 in Lancashire, England, and educated in convent schools, she met the French surrealist painter Max Ernst in the 1930s. Exhibiting with the surrealists in Paris until the Nazis interned Ernst in 1940, Carrington fled to Spain to escape the war. Committed by her family to a psychiatric hospital in Spain the following year, she subsequently escaped to Mexico in 1942 where she lived and painted until 1985. There she met Diego Rivera, Frida Kahlo and other Mexican artists.

Carrington has been credited with giving impetus to the surrealist movement in Mexico. As in the works of Max Ernst or Giorgio de Chirico, Carrington combined objects and figures in surprising juxtapositions, often relying on emotionally laden connections between animals, objects and people. Through this mixture of realistic and implausible elements Carrington exposed the viewer to the intense experiences of the artist's interior life.

The powers of Madame Phoenecia, painted in 1974, depicts an elderly woman in a heraldic pattern surrounded by various creatures, including ducks, armadillos, scorpions and goats. A believer in the 'subversive nature of female power', Carrington was inspired by Robert Graves's book The White Goddess to champion potent female figures. Drawing on ancient mythology, Celtic religion and indigenous Mexican rituals, she featured animals attributed with quasi-magical powers in her work. The supernatural talents of the old woman are symbolised by the streams of hair-like substance emanating from her nostrils. Here the subject is the relation between woman and nature. Forms of magical power are alluded to, and the entire image has the form of a religious mandala in its extreme symmetry.

Another female Mexican modernist working in a surrealist mode was María Izquierdo (1902–1955). Born in the provincial Mexican town of San Juan de los Lagos, Izquierdo moved to Mexico City in 1923 where she began to paint. She developed a repertoire of still-lifes, portraits and animal paintings which, in their gay colours and compressed space, owe much to Mexican folk and religious art. Izquierdo sought to promote the indigenous character of her painting but, like the surrealists, she distrusted folkloric or anecdotal art and aspired to stimulate the viewer's imagination. Izquierdo's paintings have an untutored look to them, but like her colleagues in Mexico City she was well informed about European art movements such as Italian Futurism and Surrealism.

The two works by Izquierdo in the Gelman collection contain depictions of horses. The earlier, Horses, painted in 1938, shows a woman accompanied by three horses standing in a landscape. Her relationship to the animals in unclear, particularly as one appears to be nuzzling her armpit. The murky, claustrophobic quality of the image, with its shallow space, evokes the landscape of dreams. Similarly, in the later Circus scene, 1940, Izquierdo has turned an ostensibly innocent subject into something troubling. At the bottom of the picture, a ballerina sits on a large hurdle blowing a trumpet. On the left, an acrobat is standing on a horse while it jumps over the same hurdle. The violent movement of the rearing horse contrasts with the strangely static pose of the rider. As Octavio Paz has argued, in Izquierdo's work, 'reality becomes ghostly, and ghosts during nights of disturbing dreams are incarnated in horses of powerful and melancholy sexuality'.[3] Her works – stylistically similar to those of her compatriots Agustín Lazo and Juan Soriano, who are also represented in the Gelman collection – are dreamlike scenes in which normal events or objects take on a mysterious, nocturnal menace.

The third component of Mexican Modernism exhibited in the Gelman collection is that of abstraction, represented by the work of two artists, Gunther Gerzso (born 1915) and Carlos Mérida (1891–1985). Mérida was born in Guatemala and only moved to Mexico in 1919 after travelling to Paris where he came into contact with European modernist painting styles such as Fauvism.

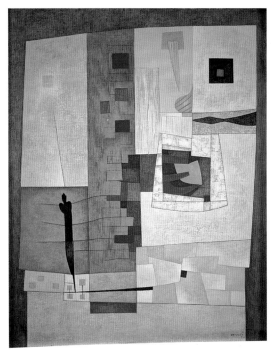

Gunther Gerzso Portrait of Mr Jacques Gelman 1957

On his return to Mexico, he joined Diego Rivera's mural painting studio and executed large-scale figurative paintings for the National Preparatory School but soon moved to abstract painting. Drawing from both Cubism and geometric abstraction, Mérida synthesised European modernism with Latin American ornamental motifs. In so doing he developed a distinctive painting technique in which geometric forms are combined in visual rhythms that evoke the sequences and variations of musical composition.

By far the most well-represented artist in the Gelman collection, Gunther Gerzso was a friend and colleague of Natasha and Jacques and worked as a set designer for the Gelman's Mexican film production company POSA Films. There are over forty works by Gerzso in the Gelman collection, only a handful of which are exhibited in the National Gallery of Australia's exhibition. Born in Mexico City, Gerzso travelled to Europe at an early age and lived with his rich art dealer uncle where he met modernist writers and artists, later going on to study architecture in Lausanne. Returning to Mexico in 1931, he began a career as a painter while working as a set designer. Gerzso started out during the 1930s in a representational style influenced by Surrealism, and in particular the Italian painter Giorgio de Chirico. In later years, he moved towards an abstract mode of painting that was influenced by his purchase of a small pre-Columbian figure from an archaeological excavation in Tlatico.

Gerzso speaks of trying to capture the spirit of the landscape in his paintings, what he calls the 'aridity, the very intense heat, that bleached atmosphere in dry stone' that he observed in Mexico and Greece.[4] His paintings are constructed somewhat like ancient villages, with irregular semi-geometric forms piled one on top of the other. The effect is often stately or austere, but in many works, such as *Portrait of Mr Jacques Gelman*, 1957, there is a sense of humour in the jaunty play of jostling forms that recalls the work of Picasso's early cubist period. In this and most of Gerzso's work, the move to abstraction does not prevent the artist from suggesting, through a kind of visual symbolism, the essence of a personality or a landscape.

Anthony White

MY MOTHER, MYSELF AND THE UNIVERSE...

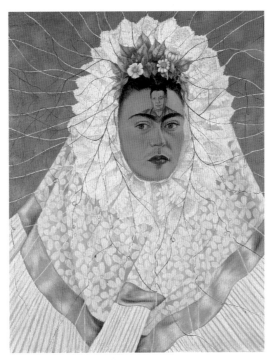

Frida Kahlo *Diego on my mind* 1953

The self-portraits of the Mexican artist Frida Kahlo (1907–1954) have captured the popular imagination. Although her physical features and elaborate costumes are striking, it is her interior life that explodes beyond the canvas. As the surrealist writer André Breton once remarked, 'The art of Frida Kahlo is a ribbon around a bomb.'[1] Kahlo's singular portrait style cuts straight to the heart of deeply felt passions and sorrows. Juxtaposing the familiar with the strange, marrying naturalistic depiction with bizarre symbolism, Kahlo is able to convince us of the truthfulness to her inner life shown in her paintings.

Frida Kahlo was born in 1907 in Coyoacán, on the outskirts of Mexico City. At the age of eighteen, she was involved in a bus accident and severely injured, leaving her with chronic ill health that would prevent her from bearing children. In 1929 she married the famous Mexican artist Diego Rivera and began a life-long, tempestuous relationship that was fractured by jealousy, infidelity and divorce. Kahlo's paintings speak of psychological and physical pain, often related to her accident and stormy marriage.

Whether Kahlo was a surrealist painter or not has been much debated. André Breton described her work as 'pure surreality', but Kahlo publicly denied knowledge of the French art movement, saying, 'I never knew I was a surrealist till André Breton came to Mexico and told me I was.'[2] We do know that Kahlo was aware of European art movements and the ideas that motivated them. Encouraged by her Austrian-born photographer father, Kahlo studied the classics of European art and literature and, while a student at the National Art Academy in Mexico City, was influenced by Italian Futurism. Like the European artists Andre Derain and Carlo Carrá, Kahlo championed the untutored art of children and indigenous peoples. She was particularly interested in the Latin American tradition of the *retablo* painting – simple religious images depicting a miraculous event in a saint's life.

Kahlo had an ambivalent relationship to the European surrealist movement. In its original formulation by Breton in 1924, Surrealism sought to 'express the functioning of the mind'.[3] As in the work of Salvador Dali and

René Magritte, objective reality in Kahlo's paintings is penetrated by bizarre elements that appear to be motivated by an interior, mental truth. Unlike her European counterparts, however, the fantastical elements of her work are never an abstract exercise in breaking down rational thought but serve to elucidate real and deeply felt psychological experiences.

A number of works in the Gelman collection bear out this argument. In *Diego on my mind*, 1943, Kahlo depicts herself in the elaborate wedding headdress worn by the Tehuantepec women of Mexico. Sarah Lowe, in her book *Frida Kahlo*, has pointed out that this image bears a close resemblance to the Catholic 'crowned sister' paintings that commemorate a nun's entry into monastic life. Just as Kahlo shows Rivera's image emblazoned on her forehead, these women were depicted crowned with flowers and bearing an image of their spiritual husband, literally becoming brides of Christ. In this painting, Kahlo picks up the idea of the 'crowned sister' paintings, comparing her marriage to Rivera, the cause of both joy and suffering

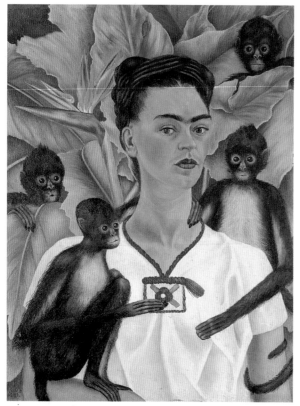

Frida Kahlo *Self-portrait with monkeys* 1943

in her life, to a nun's mystical marriage to Christ. As she wrote in her diary, 'Diego: the beginning, builder, my child, my boyfriend, painter, my lover, "my husband", my friend, my mother, me, the universe.'[4] To convey the intensity of her addictive attachment to Rivera, Kahlo appropriates elements of Christian and indigenous Mexican symbolism. She paints the sprawling threads of the dress intertwined with tendrils from the crown of flowers to express the compulsive quality of her feelings. There is a sinister air to the work that seems to subvert this testament to her passion: the strands and roots threaten to become tangled and all-enveloping, and the impassive image of Rivera's face on her forehead speaks at once of Kahlo's obsession with Rivera and of her philandering husband's indifference to her feelings.

In *Self-portrait with monkeys*, also from 1943, Kahlo depicts herself surrounded by four spider monkeys. Kahlo's own pet monkey, named Fulang-Chang, was a gift from Rivera and a surrogate for the child she was unable to bear. Although the technique in this work is highly precise, this painting is not simply a realistic portrait. The monkeys are the key to the disturbing sub-text of this painting. They peep out impishly from behind leaves, cling to Kahlo's body and toy with her clothing with their disturbingly long arms and fingers. In this image, as in many others showing her intimately associated with plants and animals, Kahlo proclaims her connection to the natural world while emphasising the unnaturalness of her childless state, a source of great despair to her. As Rivera argued in the year this image was painted, 'Frida is the only example in the history of art of an artist who tore open her chest and heart to reveal the biological truth of her feelings'.[5] The monkeys seem to mock her, but from her steely gaze we sense that she attained a kind of emotional distance from her predicament, giving birth not to children but to powerful, living documents of her interior life.

The most bizarre image in the Gelman collection is *The love embrace of the universe, the earth (Mexico), Diego, me and Señor Xolotl* of 1949. This is a complex allegorical

painting. We sense quickly that this painting is about the enormity of Kahlo's feelings for Rivera. Kahlo has depicted herself with a naked Rivera in her lap, in a familiar 'Virgin and Christ Child' pose. His staring third eye and the flames in his right hand suggest Rivera's quasi-divinity, an attribute that Kahlo connected to his prodigious creativity. The couple are embraced by an ancient pre-Columbian idol, representing the artist's native land, and complemented by a variety of Mexican flora. A river of blood flowing down Kahlo's breast, a reference to the physical suffering caused by her illness, runs parallel to the river of milk carving its way through the breast of the Mexican idol. The entire group is encircled by the arms of the universe, represented by a giant half-dark, half-light figure. Kahlo's pet dog sleeps curled up on one arm of the cosmic embrace.

This painting has been interpreted as a statement of Kahlo's forgiving acceptance of her husband's numerous infidelities. According to Kahlo's biographer, Hayden Herrera, after their remarriage in 1940 Kahlo imagined herself as Rivera's mother, allowing her to imaginatively nurture the baby she could never have, while also taking a more benign view of her husband's infidelity. As Kahlo wrote in her journal at this time: 'At every moment he is my child, my child born every moment … from myself.'[6] In this painting we see how the artist transforms their relationship into one of mother and child.

But there are deeper forces at play in this picture than a simple family romance. Kahlo inserts herself into a chain of progenitors that reaches back to the creation story. The succession of faces and embraces that cascade down the picture suggests that Kahlo is part of a universal force that is responsible for the immense creative power of her highly successful husband. As Kahlo wrote in an essay entitled 'Portrait of Diego' in the year that this work was painted:

Diego … whom the grandmother, Ancient Concealer, necessary and eternal matter, mother of men and of all the gods they invented in the delirium out of fear and hunger, WOMAN MYSELF among them all – had always wanted to hold in her arms like a newborn baby.[7]

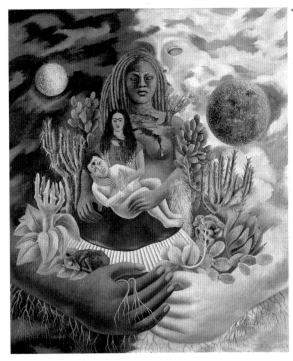

Frida Kahlo *Love embrace of the universe, the earth (Mexico), Diego, me and Señor Xolotl* 1949

At the time, Rivera may have appeared to be the sole possessor of true creativity – symbolised here by the flames burning in his hand – but Kahlo shows that power to be dependent on the presence of a feminine progenitor that is both biological and spiritual.[8] Through the outpouring of blood from her breast, Kahlo suggests that her own experience of injury enabled her to embody the very wellsprings of creativity.

A somewhat more benign but similarly unsettling self-portrait is concealed in the 1943 painting called *The bride who became frightened when she saw life opened*. The extraordinary botanical details are what first catch our eye – the prickly fur of the coconut's shell, the sharp ribbons of the pineapple bloom, the juicy open slices of watermelon flesh pierced by black seeds. The title mentions a 'bride'. In this painting she is present as the little doll hiding behind a quarter of melon. This toy, bought by Kahlo from a Paris flea market, links her work to the surrealists, who used similar 'found objects' in their work. Far from being a conventional still-life painting, this work harbours numerous visual surprises that deepen our perception of the work's meaning the further we look.

Kahlo painted many still-lifes throughout her career which took on increasingly erotic and menacing overtones, and this painting is no exception. Sharing the space of the distorted yellow tabletop with the fruit and doll are a brooding owl with a staring eye and a grasshopper perched curiously on a hand of ripe bananas. The fruit is positively anthropomorphic and alive in its suggestions of human genitals and faces. The exotic animals are, by contrast, static and inscrutable. Life, Kahlo seems to be saying, presents formidable challenges to a young girl reaching womanhood. She must negotiate the almost unbearable vitality of the natural world's fecundity and the alien strangeness of the beings who populate it. Although the work suggests that innocence is bound to be lost, Kahlo does not ask us to turn away from life but to embrace it, to open ourselves to all of its startling variety.

The remaining works in the Gelman collection are relatively straightforward self-portraits or paintings of other important people in Kahlo's life, including Diego Rivera and Natasha Gelman. The self-portraits show Kahlo in the same three-quarter profile, her piercing gaze directed at the viewer, in different costumes and hairstyles. After her marriage to Rivera, Kahlo favoured native Mexican attire and jewellery in a conscious rejection of conventional standards of twentieth century, middle-class dress, but also as a way of promoting the indigenous, regional culture of less privileged Mexican people.[9] On one level, these paintings are a forceful statement of solidarity with the culture of her homeland. On another, they expose the self-conscious nature of that allegiance: as the daughter of a German parent living in urban Mexico, her Mexicanness had a degree of affectation to it. The extravagance of her dress made it vulnerable to appropriation, and it was briefly taken up by haute couture fashion designers in New York and Paris and was adopted as a conscious style by Schiaparelli.[10]

None of this detracts from Kahlo's felt connection to native Mexican culture which, in her portraits, gave her the opportunity to project powerful emotions onto the exotic and unusual details of regional dress. Just as the use of the Tehuantepec marriage costume in the portraits enabled her to convey feelings of being wedded to husband and nature, so the contrasts of delicate hand-worked fabric and earthy ornaments enabled her to express two different sides of her personality.

Hair had special significance in Kahlo's life. In 1940 after her divorce from Rivera, she painted herself with cropped hair. In the following year, reunited with Diego, she painted two portraits in which she wears elaborate hairstyles. In *Self-portrait with braid*, the combined plaited rope and hair seems to have a life of its own. Like the curling fronds of vegetation around her naked shoulders, it threatens to engulf her body with its unruly, snake-like knots. If in imaginatively reclaiming her long hair this painting conveys a spirit of reconciliation with Rivera, we sense from the elements that it may have been an unstable truce that still threatened to come apart at the seams.

Anthony White

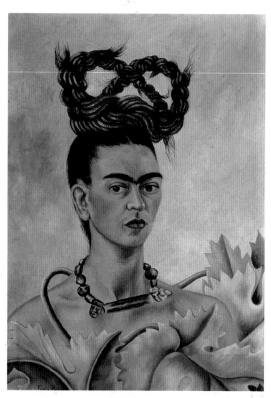

Frida Kahlo *Self-portrait with braid* 1941

CATALOGUE
OF WORKS

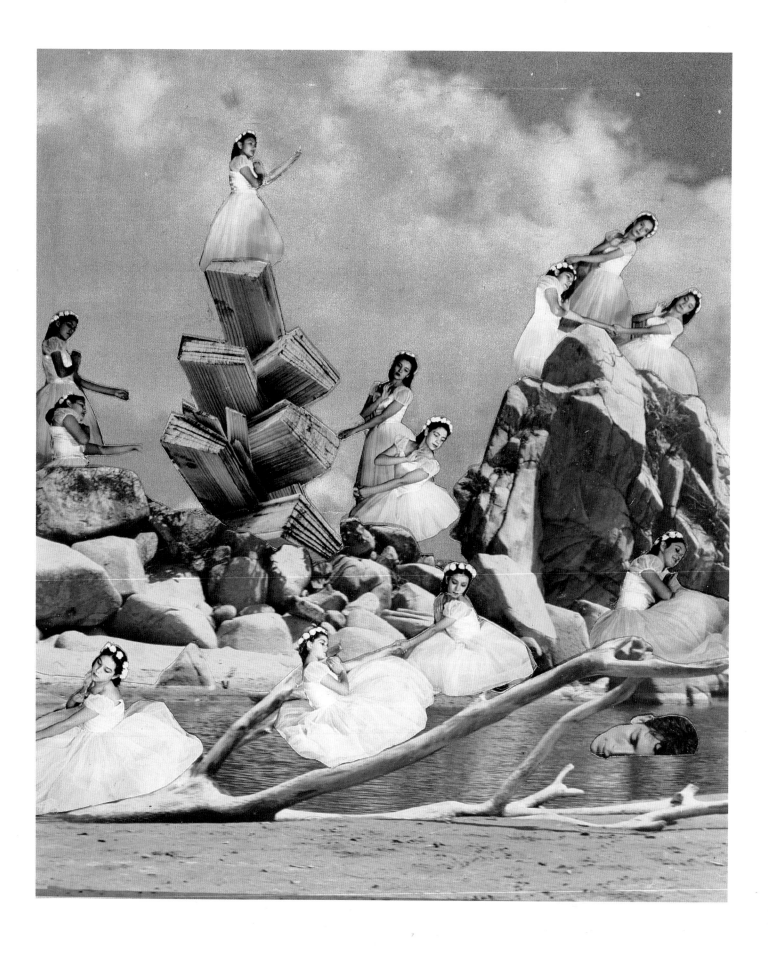

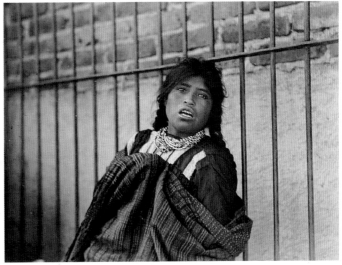

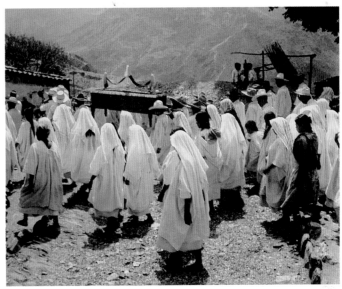

(opposite) **Lola Alvarez Bravo** *El sueño del ahogado* [The dream
of the drowned] c.1945
(above) *Soñando* [Dreaming] 1945
(above right) *Culpas ajenas* [Faults of others] 1948
(right) *Entierro de Yalalag* [Burial at Yalalag] 1946
(previous page) **Manuel Alvarez Bravo** *Organo cacti (No. 36)*
[Organ cacti (No. 36)] 1929–1930

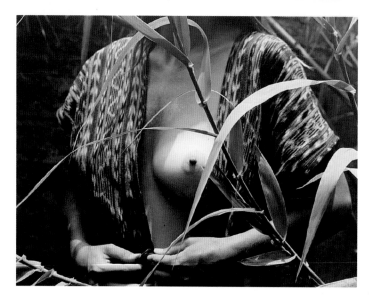

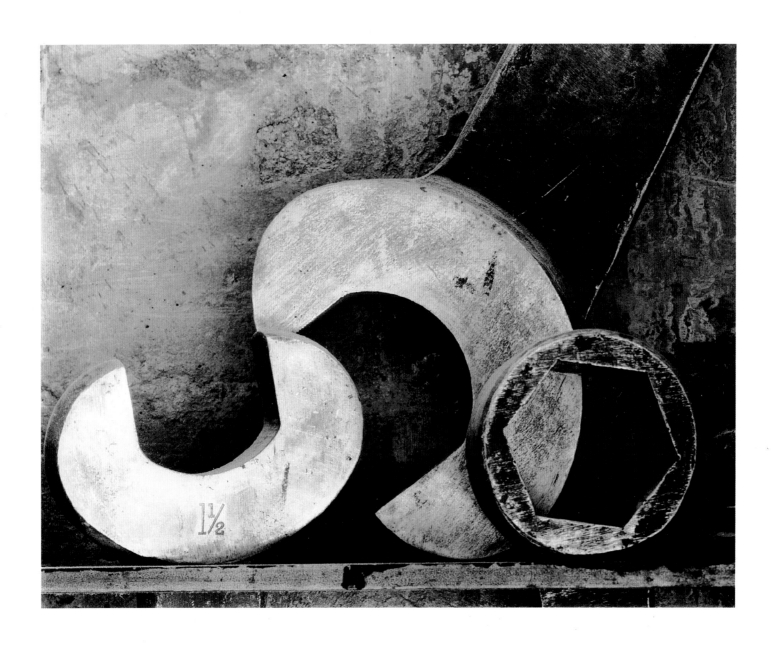

(above) **Manuel Alvarez Bravo** *El instrumental* [The instruments] 1931
(opposite above) *Colchón (negative) No. 1* [Mattress (negative) No. 1] 1927
(opposite centre) *Pan nuestro (No. 3)* [Our daily bread (No. 3)] 1929
(opposite below) *Fruta prohibida (No. 2)* [Forbidden fruit (No. 2)] 1976

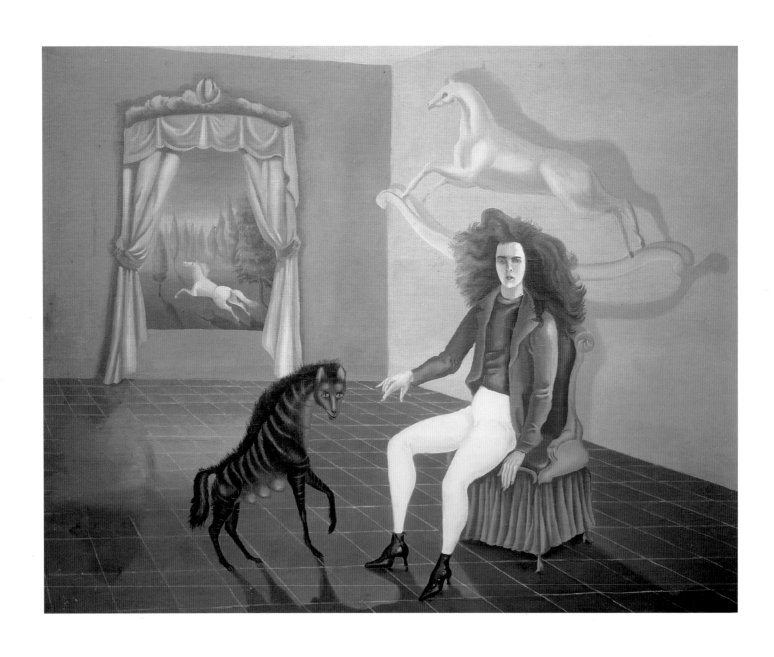

Leonora Carrington *Autoportrait à l'Auberge du Cheval de l'Aube* [Self-portrait at the Dawn Horse Inn] 1936–1937

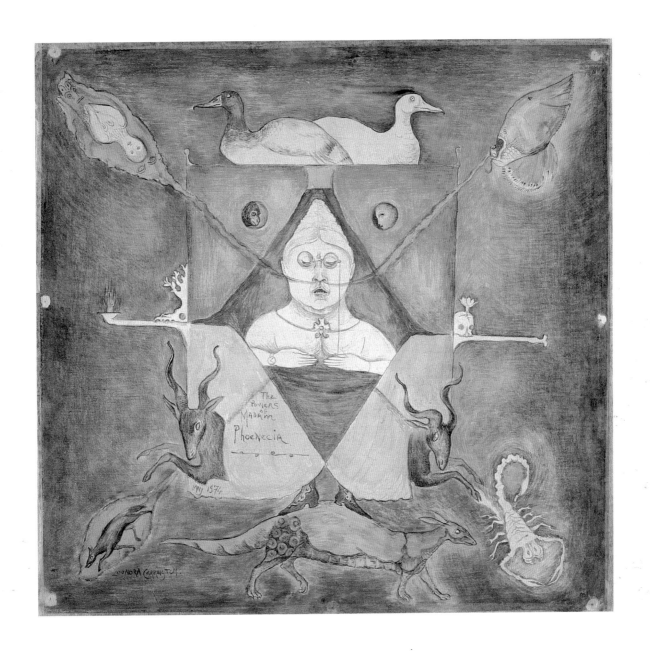

Leonora Carrington *Los poderes de Madame Phoenecia* [The powers of Madame Phoenecia] 1974

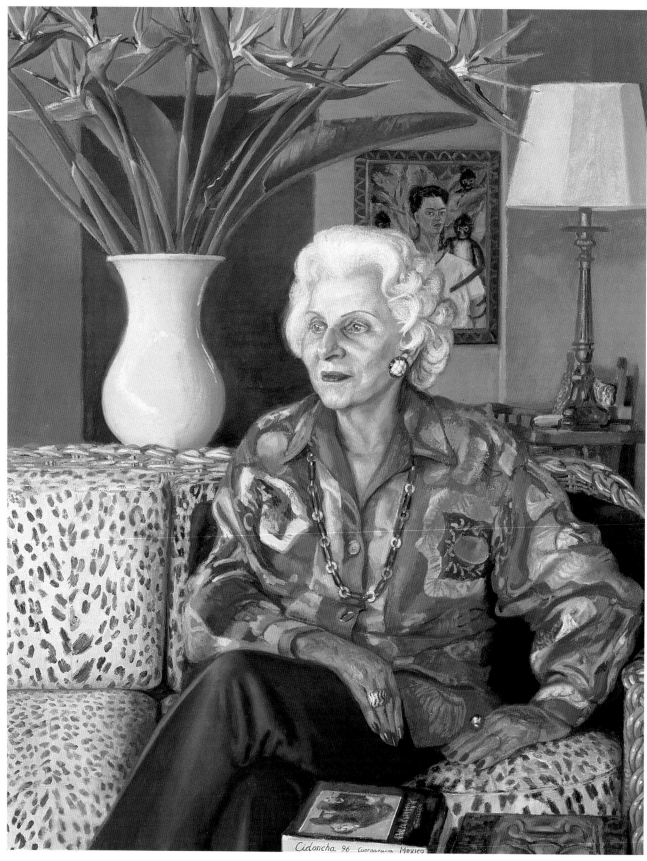

Rafael Cidoncha *Retrato de la Señora Natasha Gelman* [Portrait of Mrs Natasha Gelman] 1996

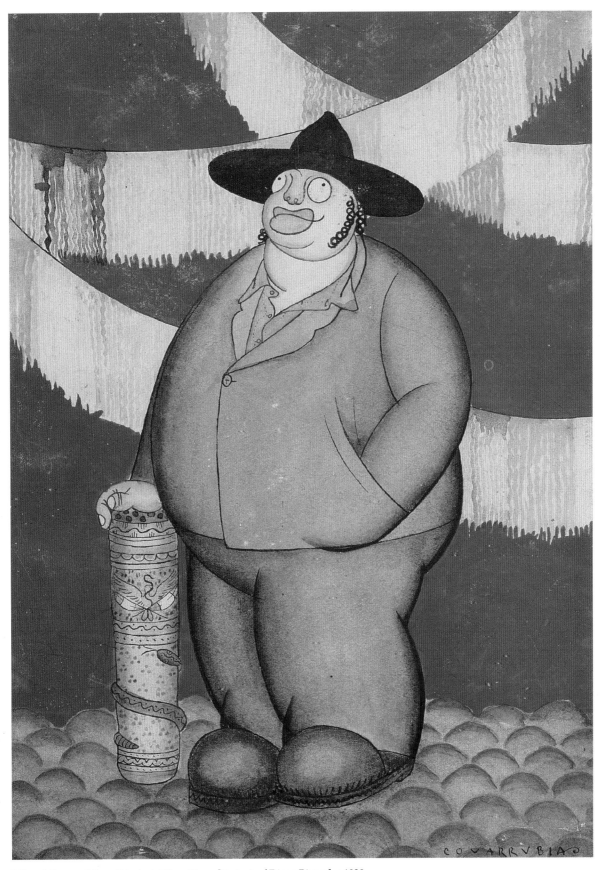

Miguel Covarrubias *Retrato de Diego Rivera* [Portrait of Diego Rivera] *c.*1920

 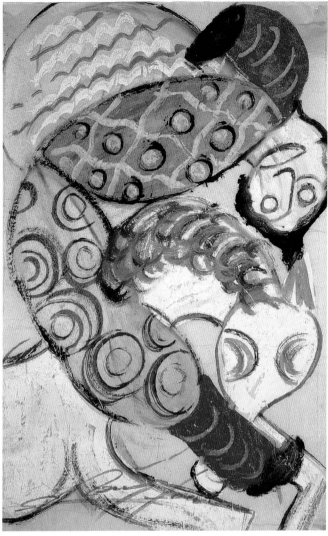

(opposite) **Jesús Reyes Ferreira** *El adiós* [The farewell] not dated
(above left) *El florero* [Flower vase] not dated
(above right) *Sin título* [Untitled] not dated

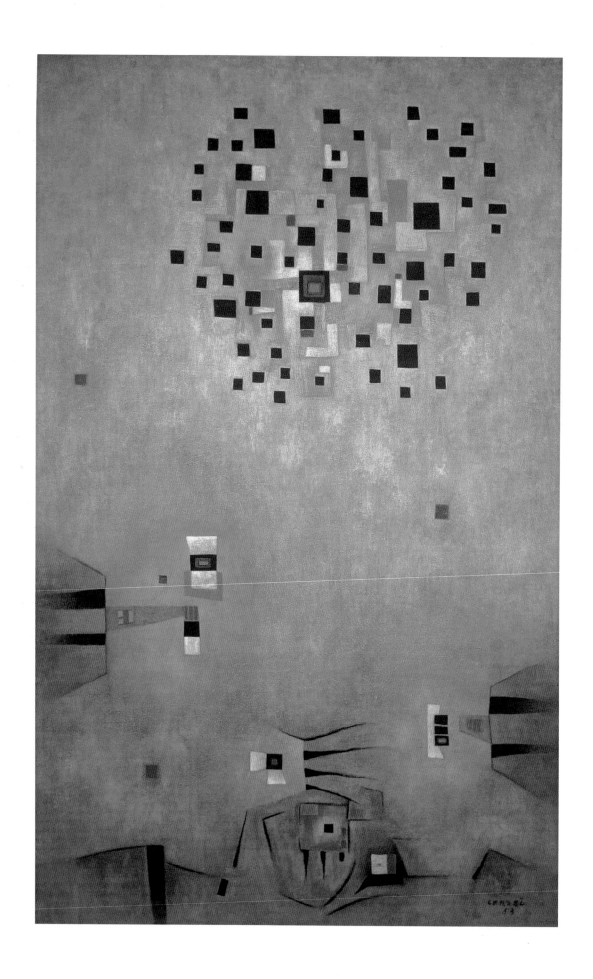

(opposite) **Gunther Gerzso** *Los cuatro elementos* [The four elements] 1953
(above) *El gato de la Calle Londres I* [The cat from London Street I] 1954

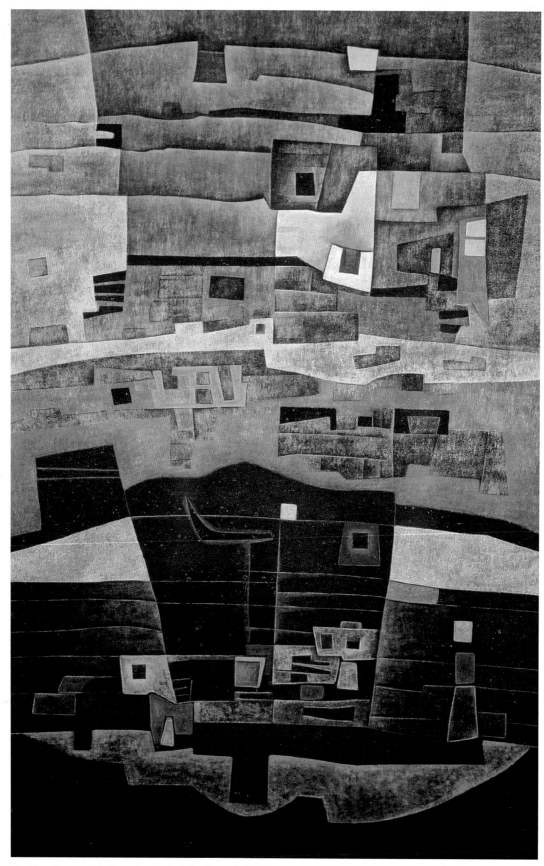

Gunther Gerzso *Paisaje arcaico* [Archaic landscape] 1956

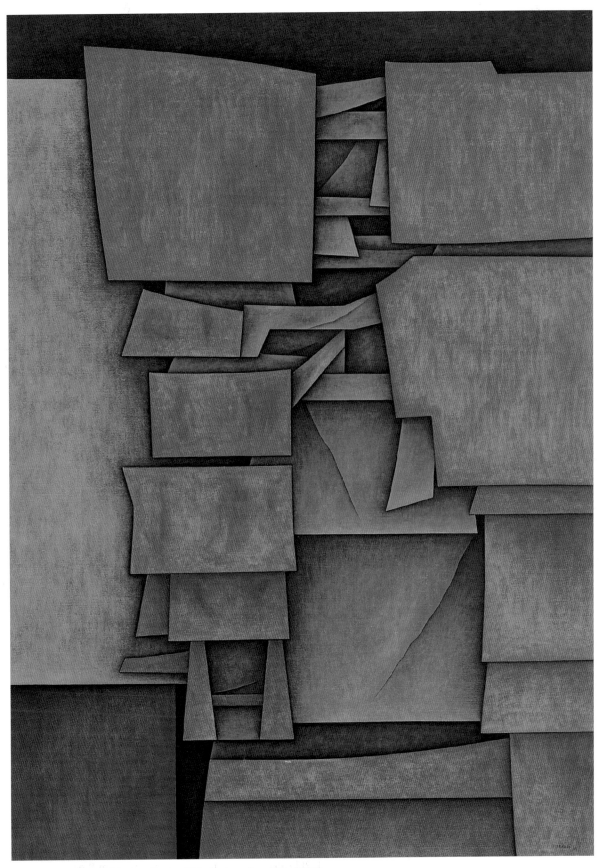

Gunther Gerzso *Personaje en rojo y azul* [Figure in red and blue] 1964

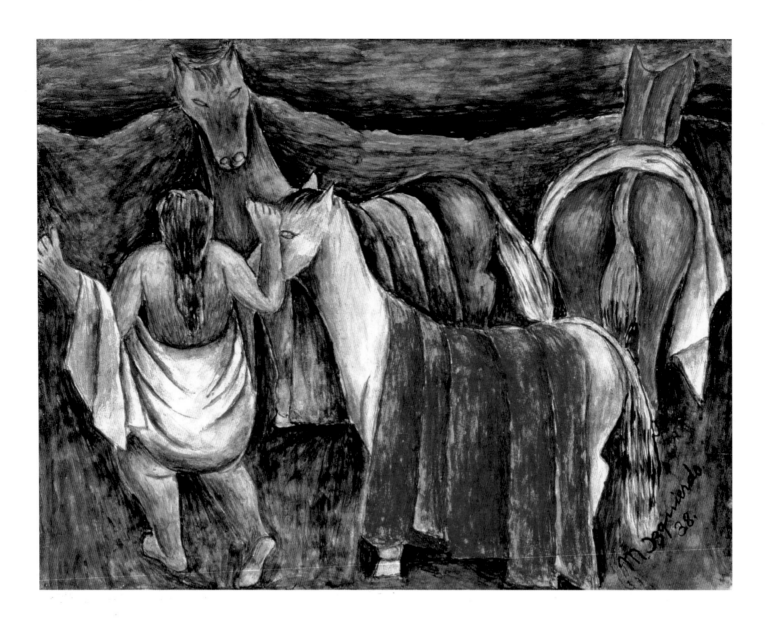

María Izquierdo *Los caballos* [Horses] 1938

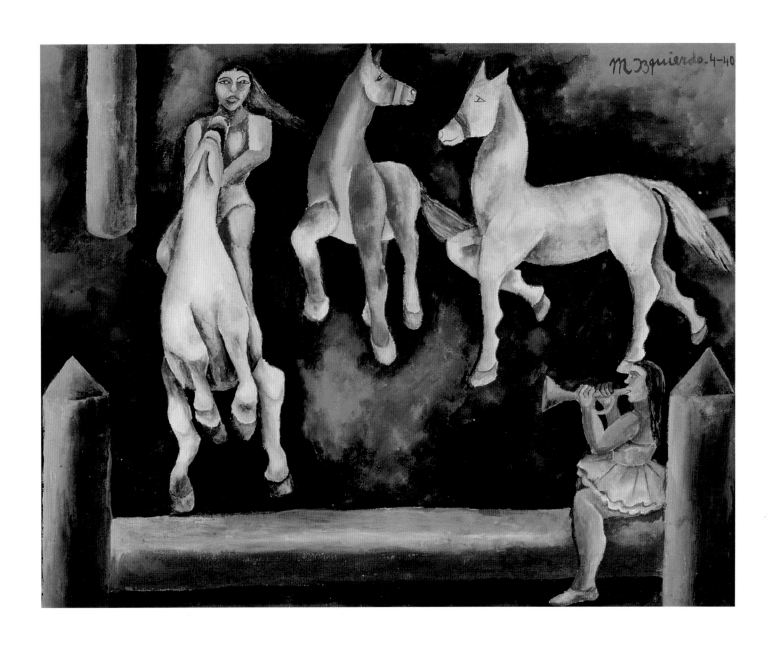

María Izquierdo *Escena de circo* [Circus scene] 1940

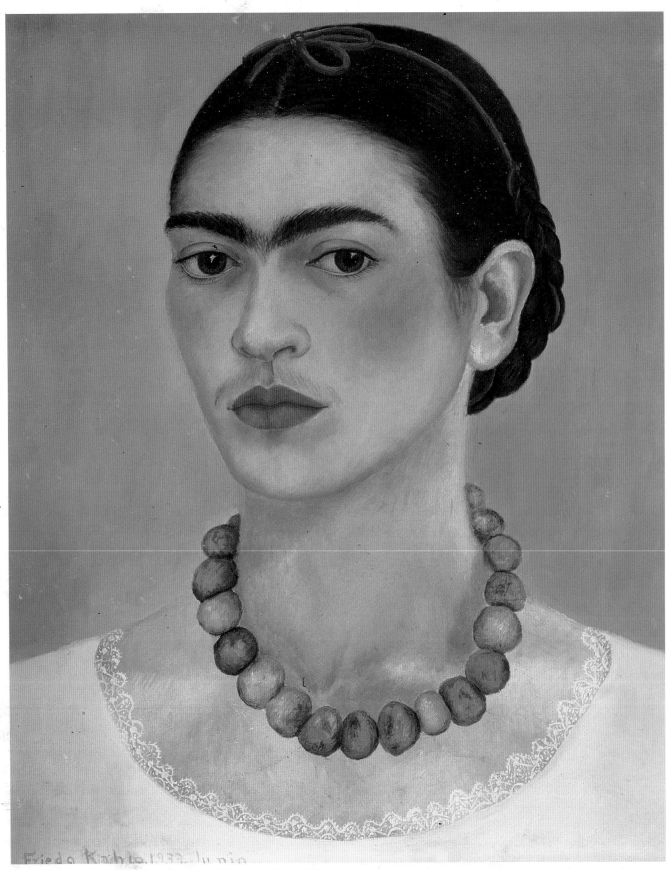

Frida Kahlo *Autorretrato con collar* [Self-portrait with necklace] 1933

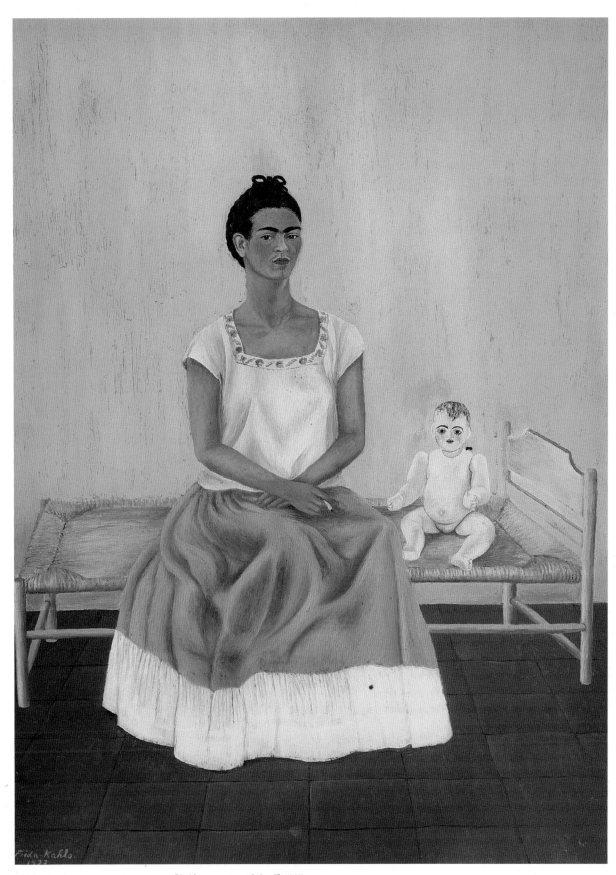

Frida Kahlo *Autorretrato con cama* [Self-portrait with bed] 1937

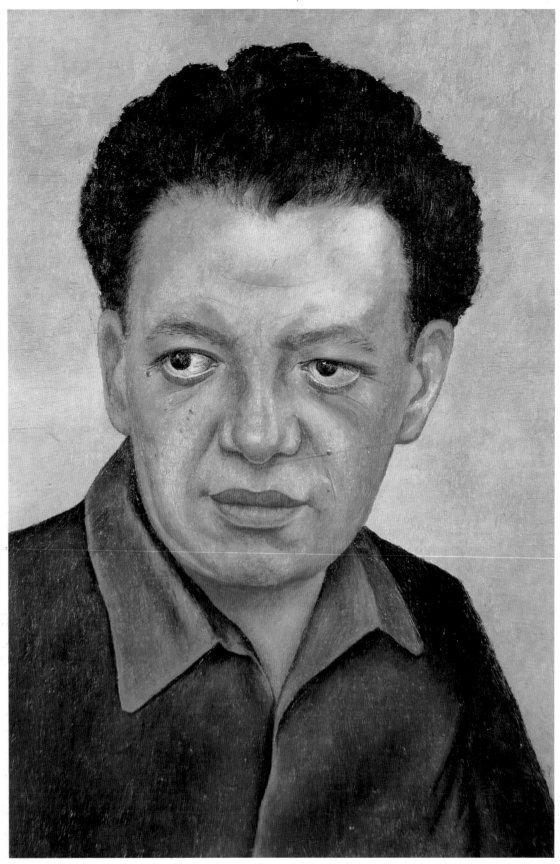

Frida Kahlo *Retrato de Diego Rivera* [Portrait of Diego Rivera] 1937

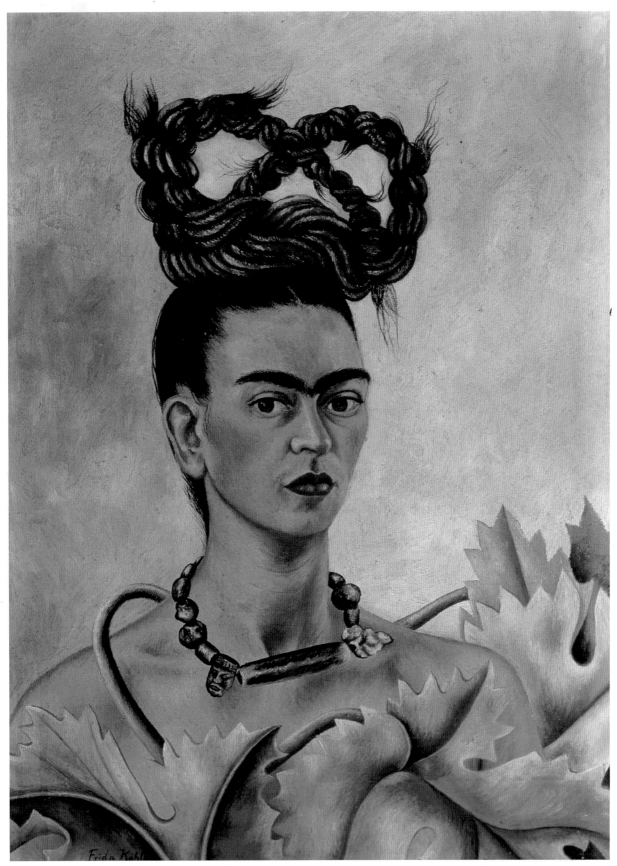

Frida Kahlo *Autorretrato con trenza* [Self-portrait with braid] 1941

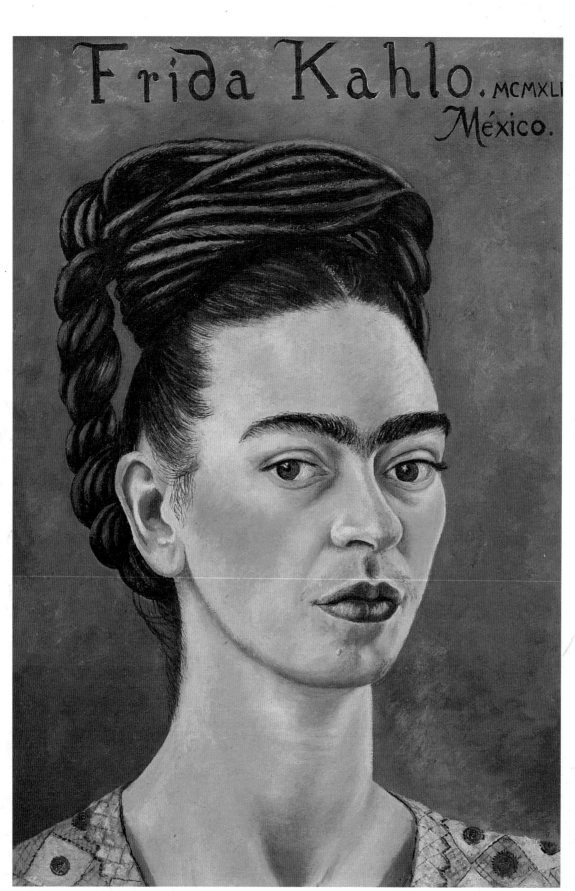

Frida Kahlo *Autorretrato con vestido rojo y dorado* [Self-portrait with red and gold dress] 1941

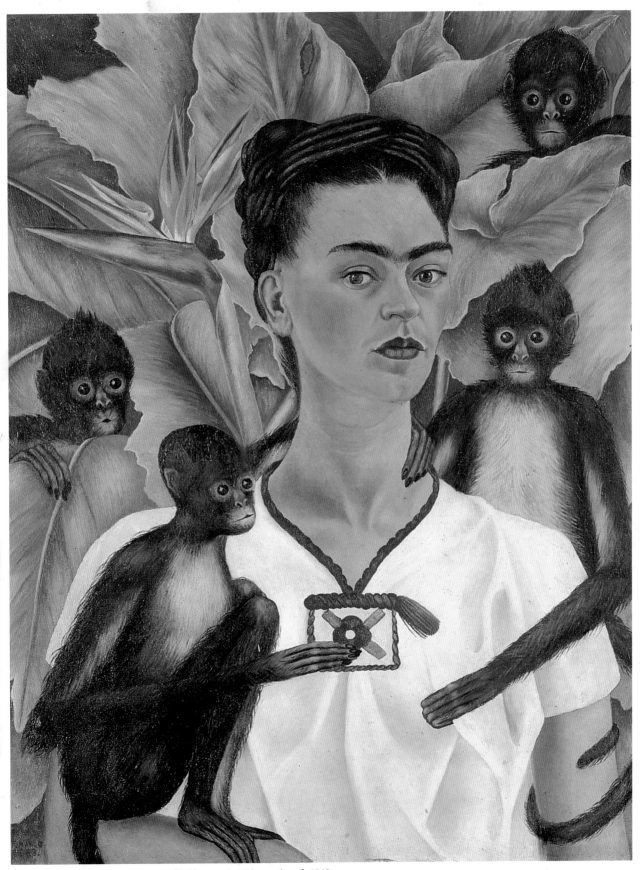

Frida Kahlo *Autorretrato con monos* [Self-portrait with monkeys] 1943

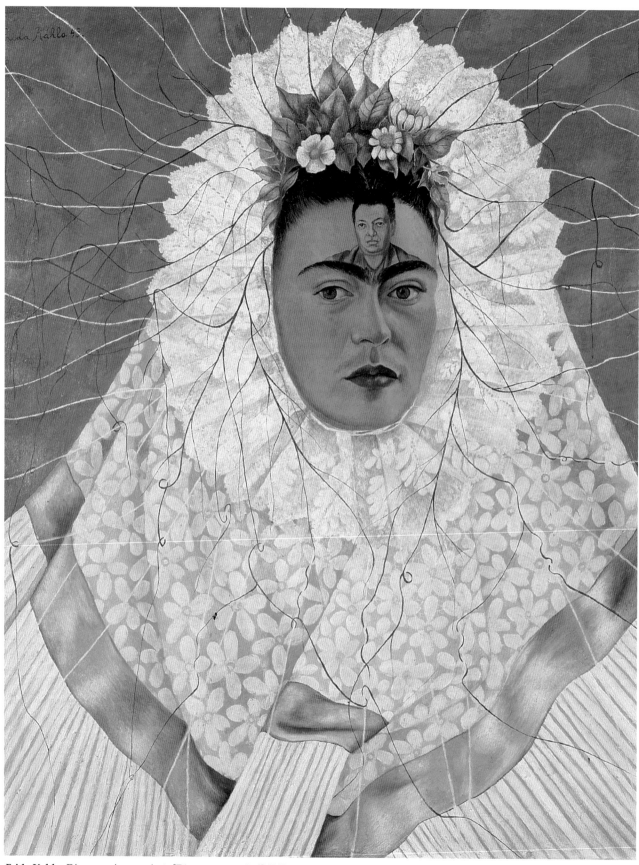

Frida Kahlo *Diego en mi pensamiento* [Diego on my mind] 1943

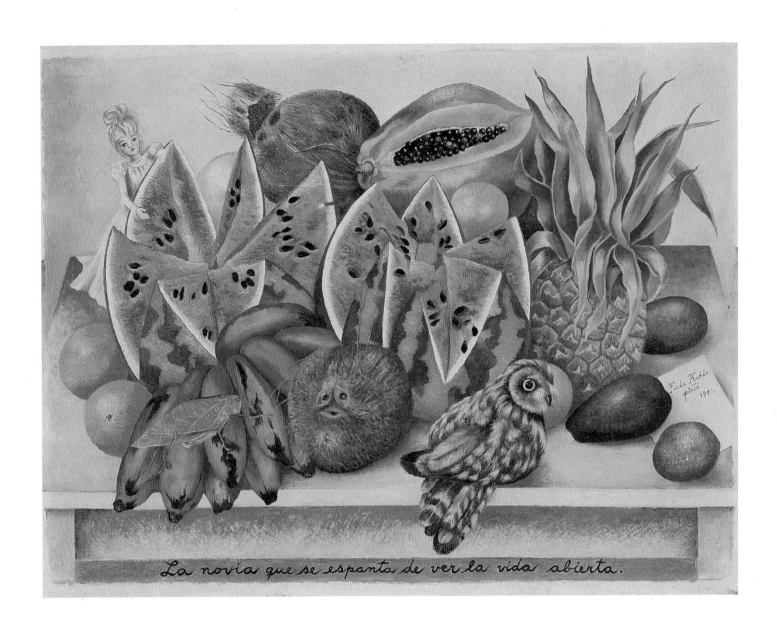

La novia que se espanta de ver la vida abierta.

Frida Kahlo *La novia que se espanta de ver la vida abierta* [The bride who became frightened when she saw life opened] 1943

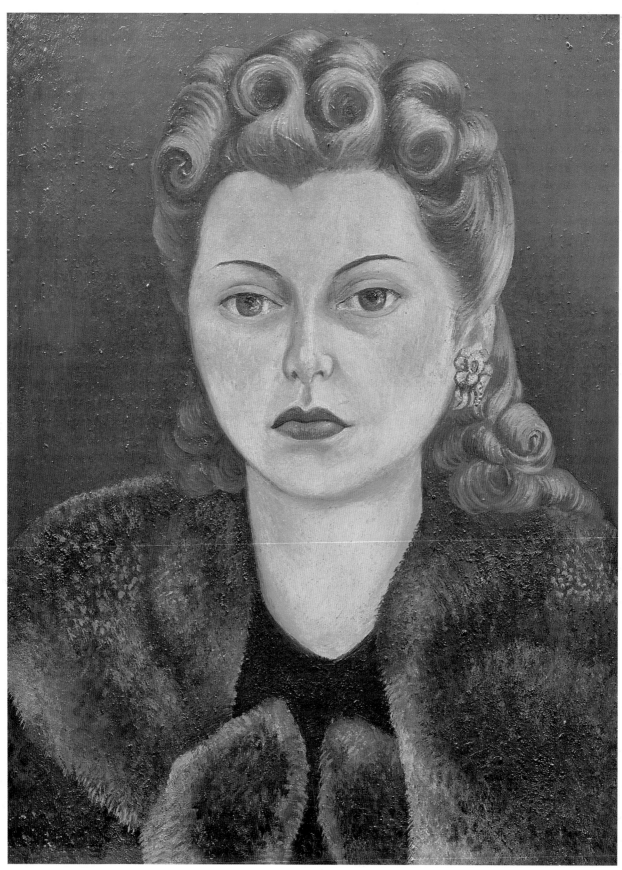

Frida Kahlo *Retrato de la Señora Natasha Gelman* [Portrait of Mrs Natasha Gelman] 1943

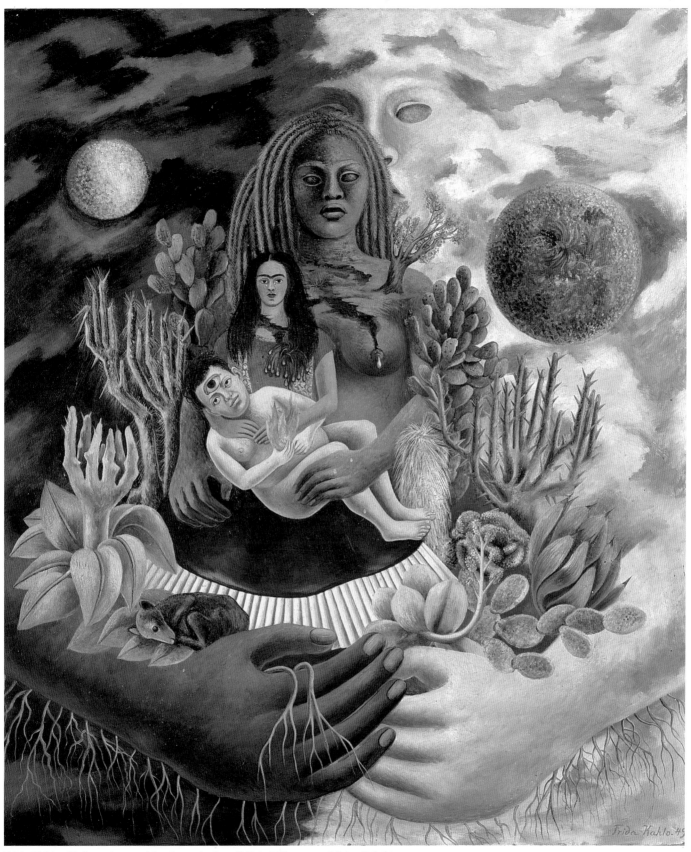

Frida Kahlo *El abrazo de amor del universo, la tierra (México) Diego, yo y el Señor Xolotl*
[The love embrace of the universe, the earth (Mexico) Diego, me and Señor Xolotl] 1949

Frida Kahlo *Karma I* 1946
Dibujo con un pie a la izquierda y senos a la derecha [Drawing with a foot on the left and breasts on the right] 1946

Agustín Lazo *Juegos peligrosos* [Dangerous games] *c.*1930–1932

(above) **Agustín Lazo** *Fusilamiento* [Execution by firing squad] *c.*1930–1932
(below) *Robo al banco* [Bank robbery] *c.*1930–1932

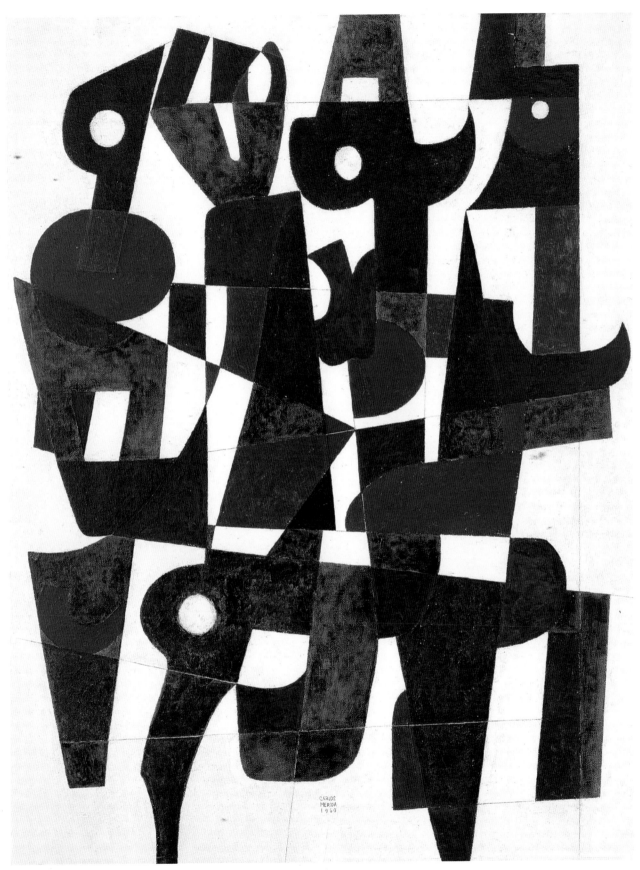

Carlos Mérida *Variación de un viejo tema* [Variations on an old theme] 1960

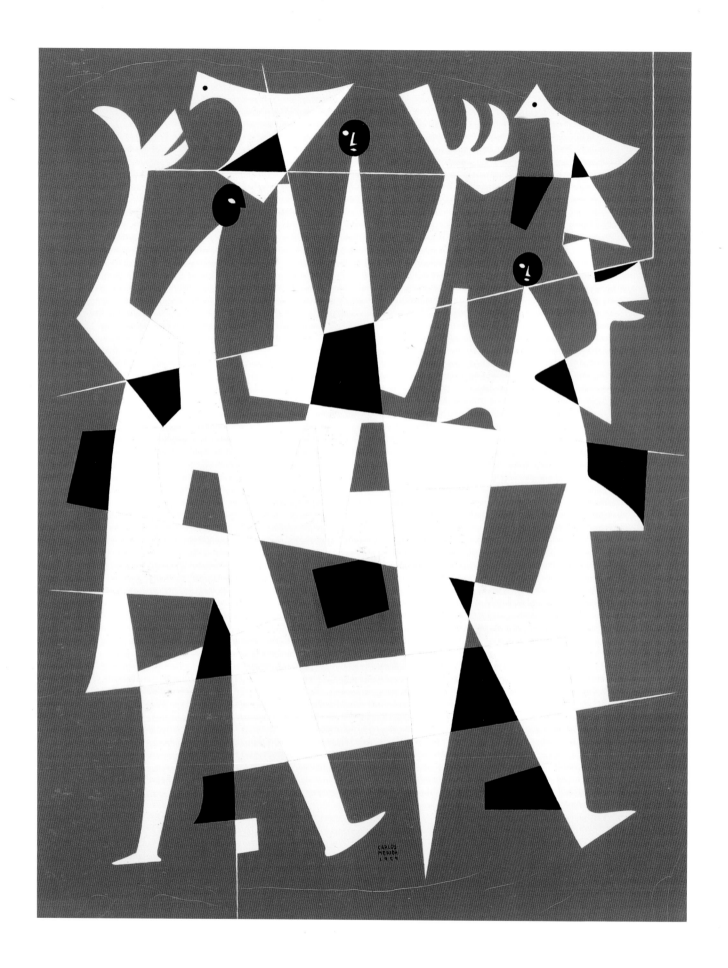

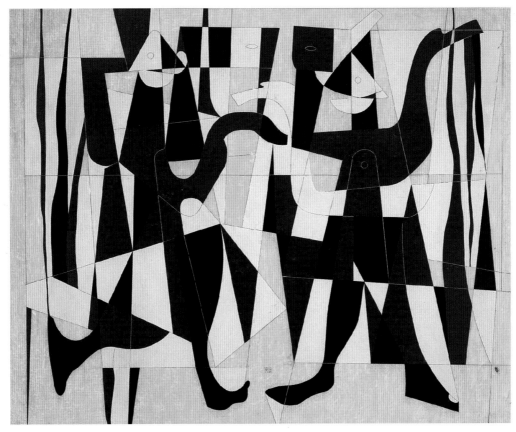

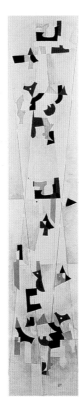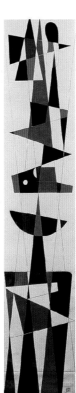

(opposite) **Carlos Mérida** *Fiesta de pájaros* [Festival of the birds] 1959
(above) *El mensaje* [The message] 1960
(below) *Cinco paneles* [Five panels] 1963

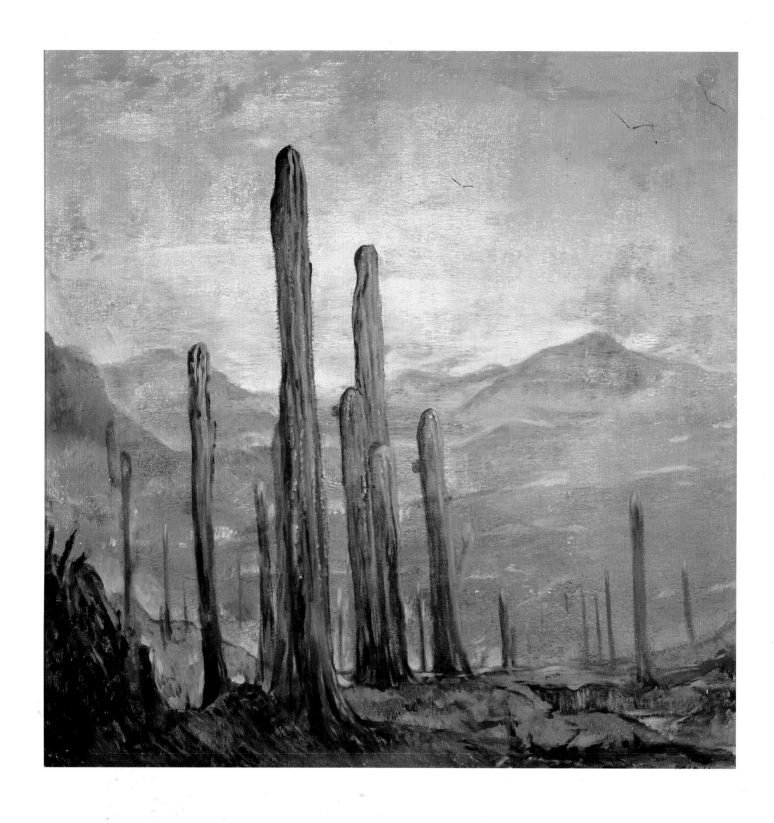

Roberto Montenegro *Amanecer* [Dawn] 1950

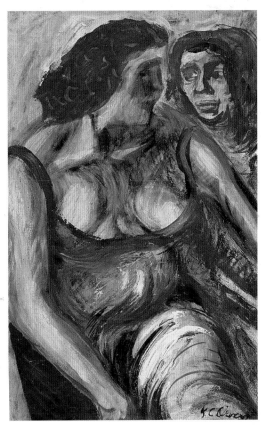

(above) **José Clemente Orozco** *Sin título*
(Salón México) [Untitled (Salon Mexico)] 1940
(right) *Pintura* [Painting] 1942

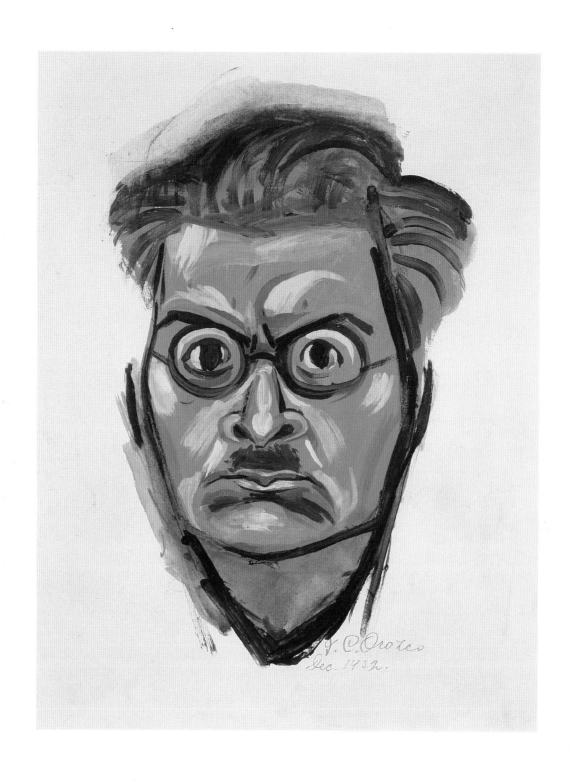

José Clemente Orozco *Autorretrato* [Self-portrait] 1932

Carlos Orozco Romero *Danzantes* [Dancers] not dated

Carlos Orozco Romero *Entrada al infinito* [Entrance to infinity] 1936

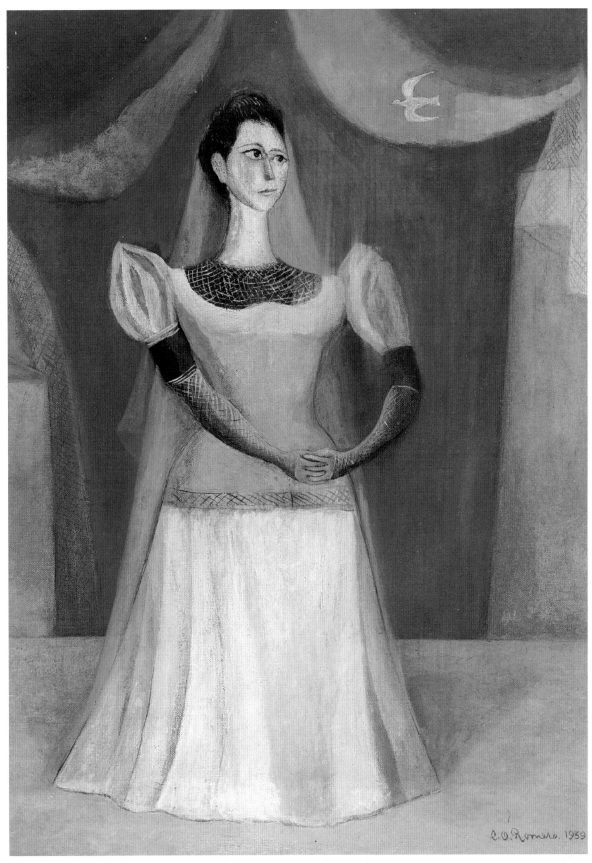

Carlos Orozco Romero *La novia* [The bride] 1939

Carlos Orozco Romero *Protesta* [Protest] 1939

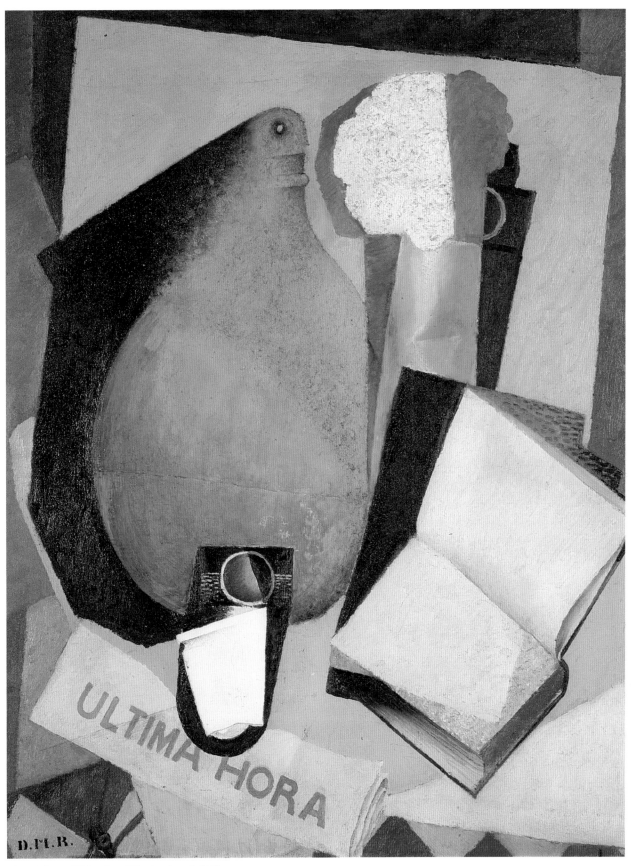

Diego Rivera *Ultima hora* [The last hour] 1915

Diego Rivera *Paisaje con cactus* [Landscape with cactus] 1931

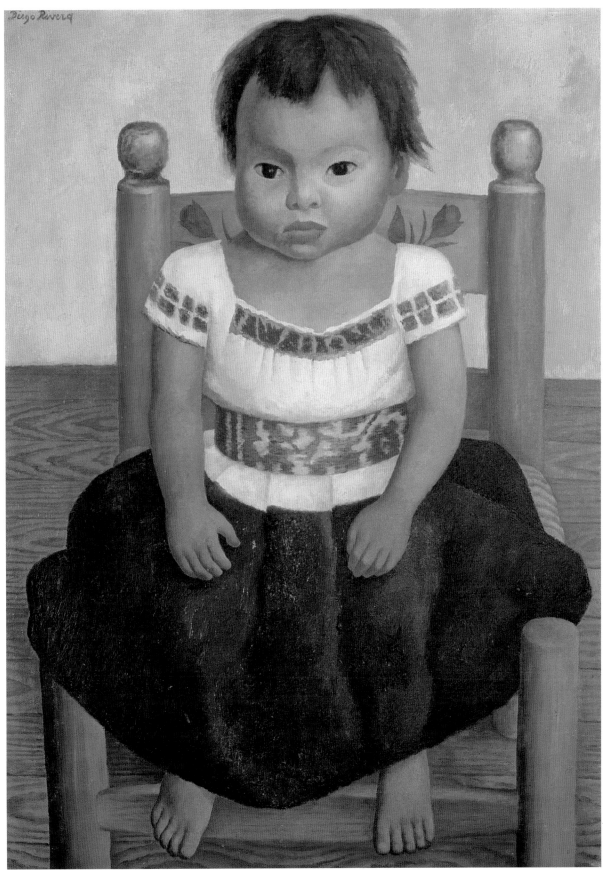

Diego Rivera *Modesta* [Modesta] 1937

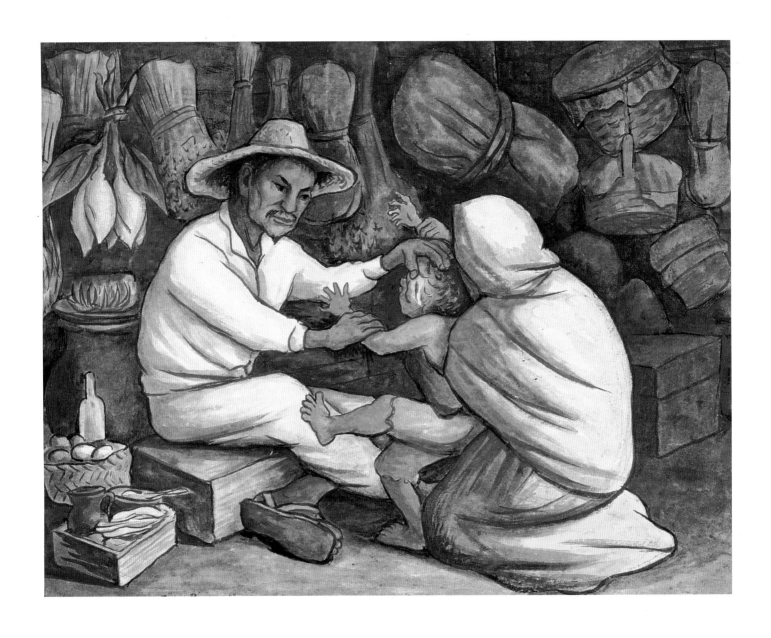

Diego Rivera *El curandero* [The healer] 1943

Diego Rivera *Girasoles* [Sunflowers] 1943

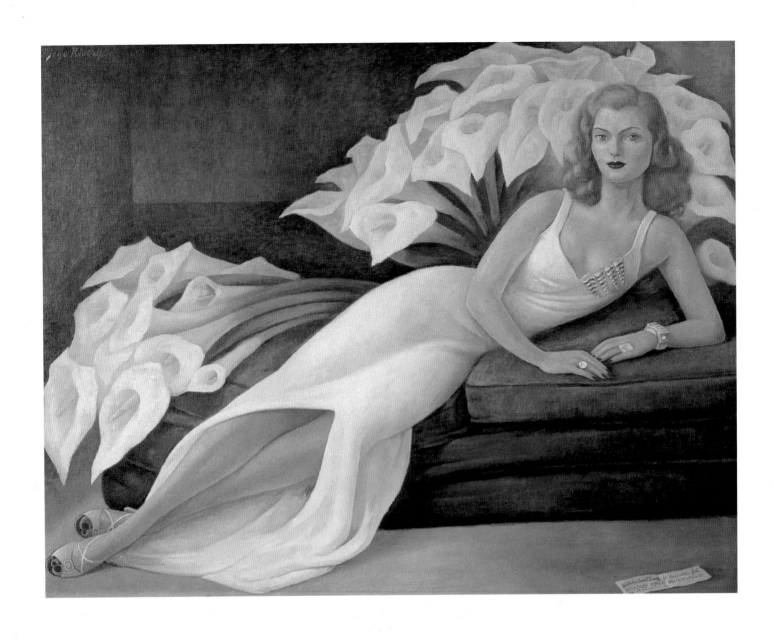

Diego Rivera *Retrato de la Señora Natasha Gelman* [Portrait of Mrs Natasha Gelman] 1943

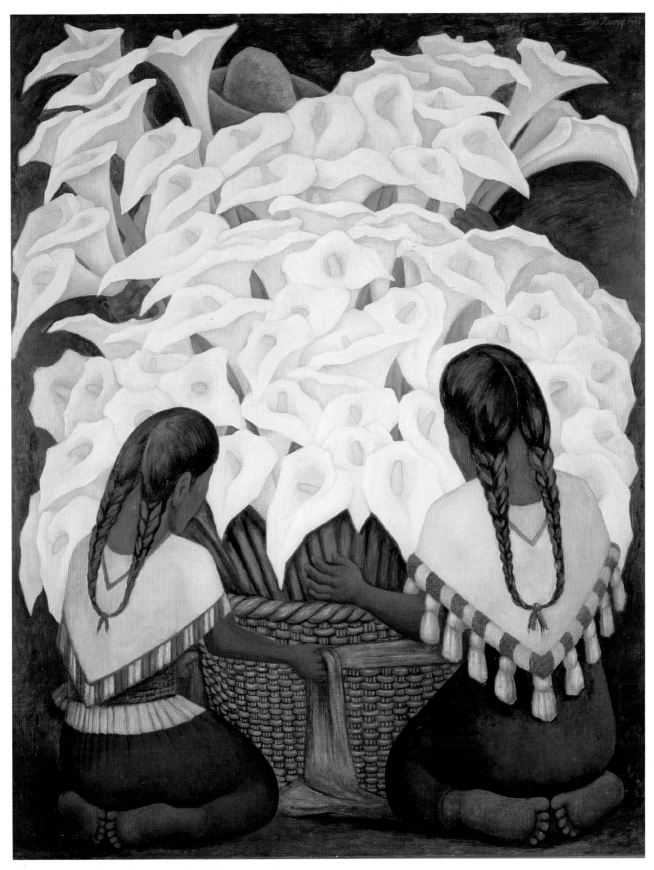

Diego Rivera *Vendedora de alcatraces* [Calla lily vendor] 1943

(above left) **David Alfaro Siqueiros** *Siqueiros por Siqueiros*
[Siqueiros by Siqueiros] 1930
(above) *Cabeza de mujer* [Head of a woman] 1939
(left) *Retrato de la Señora Natasha Gelman*
[Portrait of Mrs Natasha Gelman] 1950
(opposite) *Mujer con rebozo* [Woman with shawl] 1949

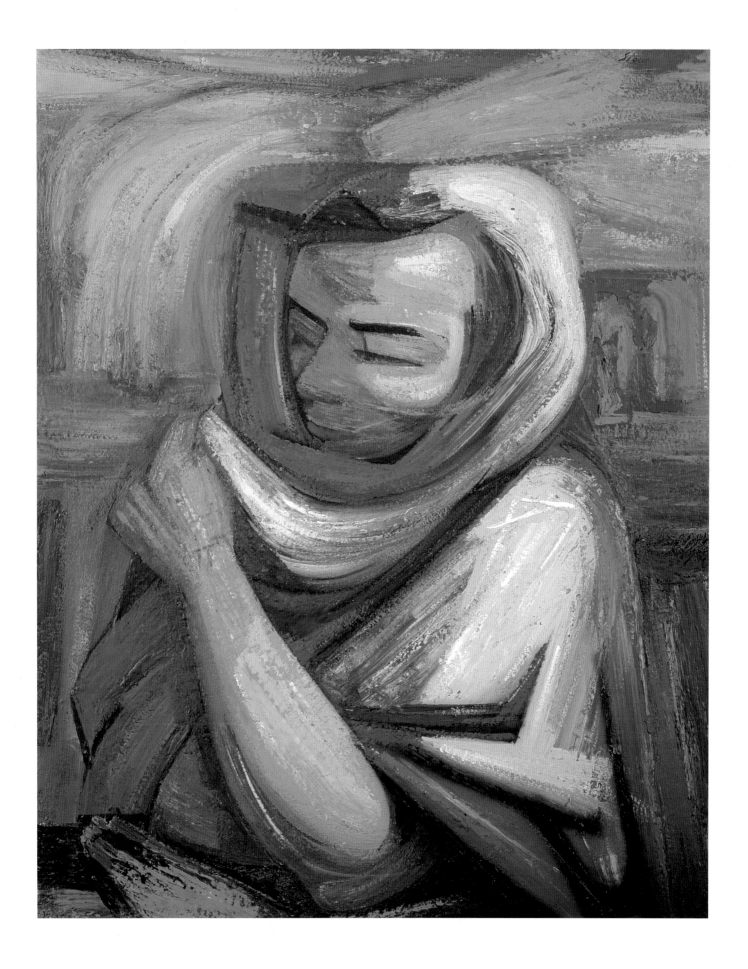

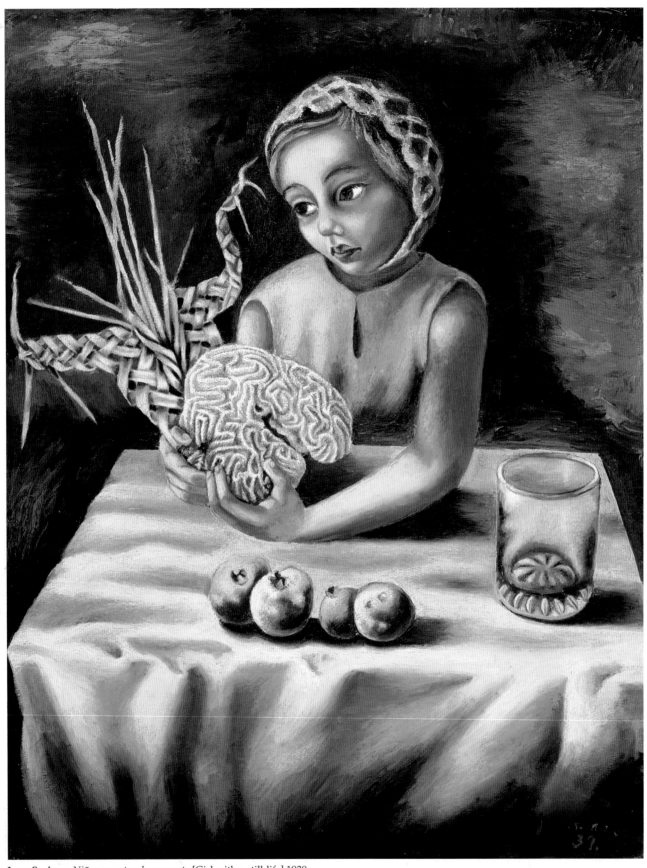

Juan Soriano *Niña con naturaleza muerta* [Girl with a still-life] 1939

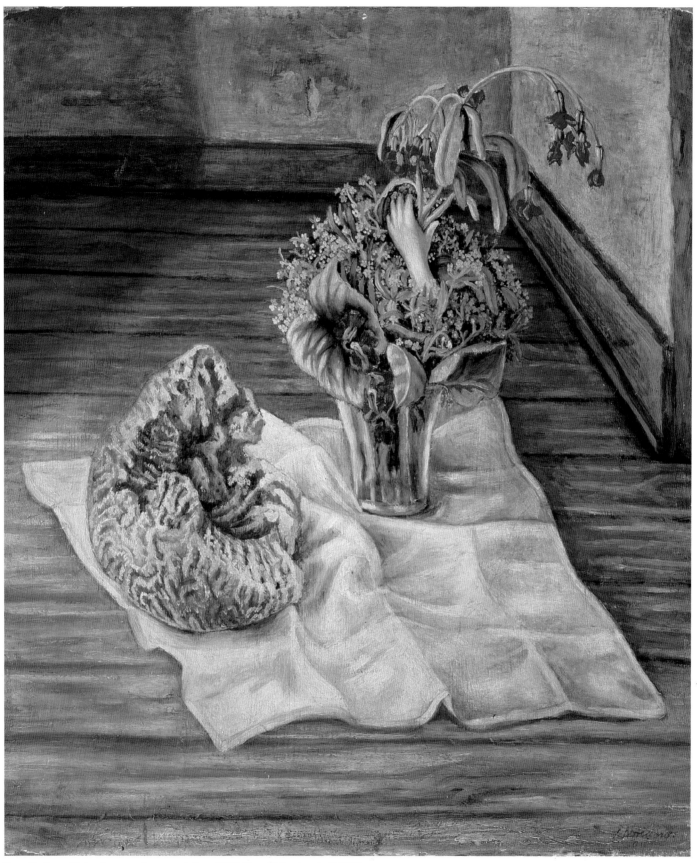

Juan Soriano *Naturaleza muerta con madrépora* [Still-life with brain coral] 1944

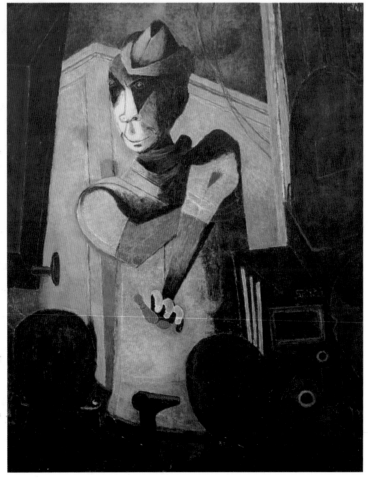

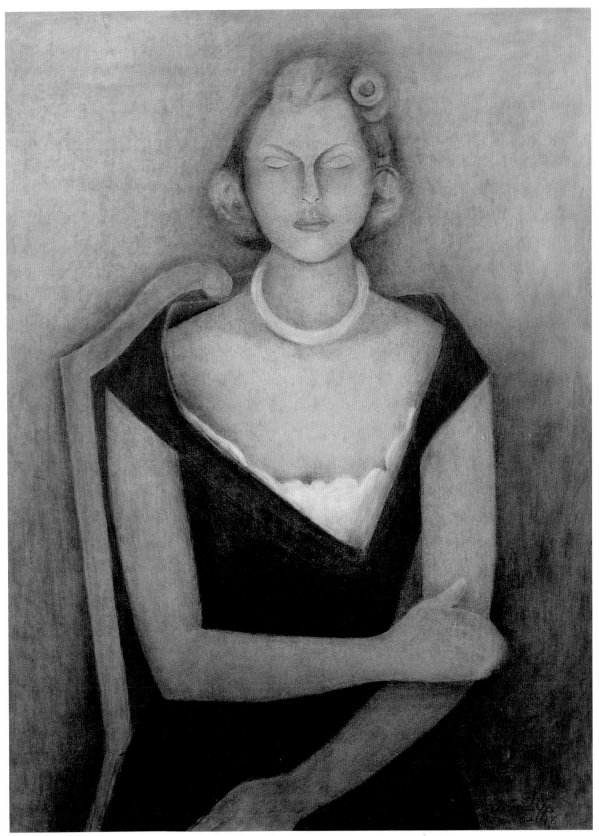

(above) **Rufino Tamayo** *Retrato de la Señora Natasha Gelman* [Portrait of Mrs Natasha Gelman] 1948
(opposite above) *Rooftops* 1925
(opposite below) *Retrato de Cantinflas* [Portrait of Cantinflas] 1948

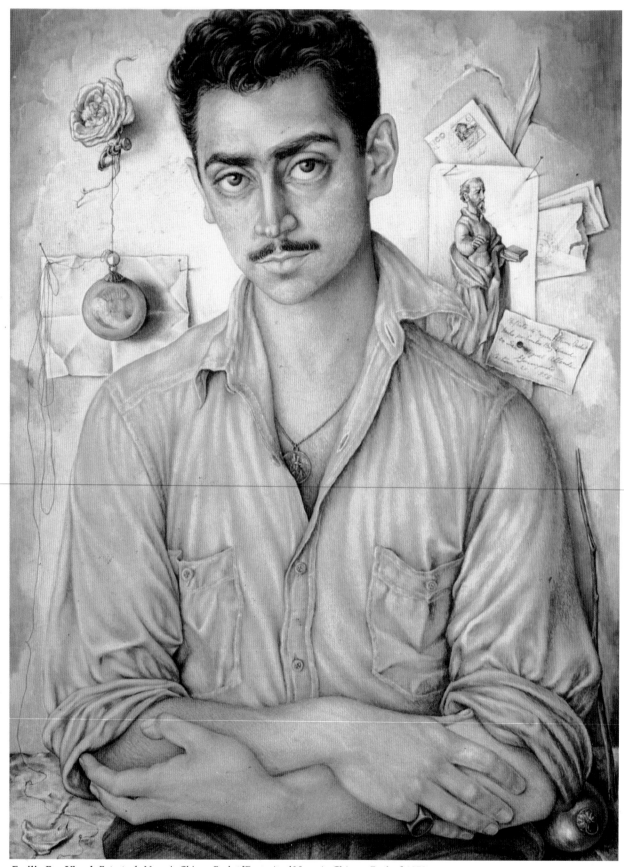

Emilio Baz Viaud *Retrato de Nazario Chimez Barket* [Portrait of Nazario Chimez Barket] 1952

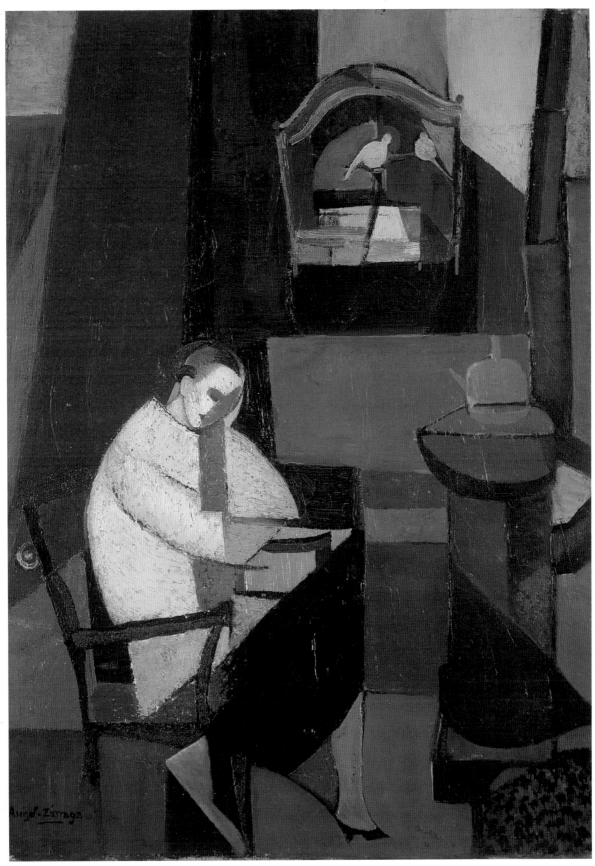

Angel Zárraga *Sin título* [Untitled] *c.*1915–1917

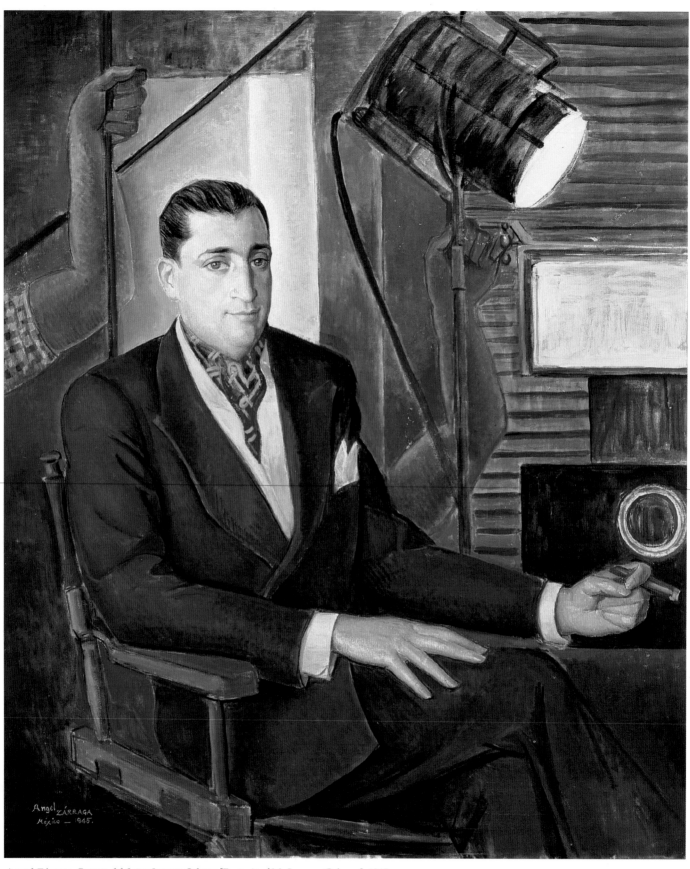

Angel Zárraga *Retrato del Señor Jacques Gelman* [Portrait of Mr Jacques Gelman] 1945

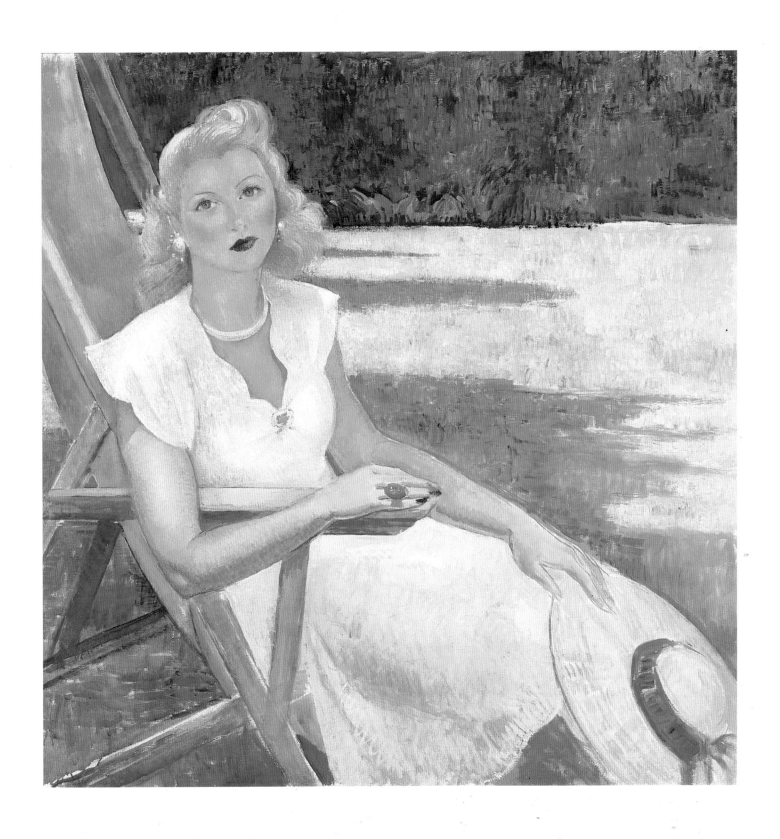

Angel Zárraga *Retrato de la Señora Natasha Gelman* [Portrait of Mrs Natasha Gelman (unfinished)] *c*.1946

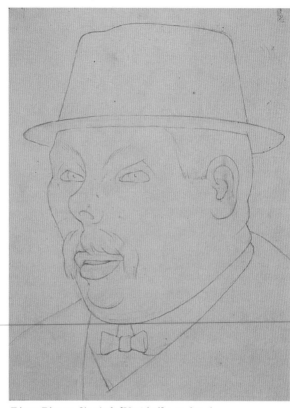

Diego Rivera *Sin título* [Untitled], not dated

LIST OF WORKS

All works belong to the Vergel
Foundation, New York, unless otherwise
indicated

Lola Alvarez Bravo
Torito [Little bull] not dated
gelatin silver print
19.1 x 21.6 cm

Alameda central [Central Alameda] 1945
gelatin silver print
17.8 x 22.9 cm

Erongarícuaro 1945
gelatin silver print
19.1 x 21.6 cm

Soñando [Dreaming] 1945
gelatin silver print
22.9 x 17.8 cm

El sueño del ahogado
[The dream of the drowned] *c.*1945
photo collage and ink
26.0 x 22.0 cm

Entierro de Yalalag [Burial at Yalalag] 1946
gelatin silver print
19.1 x 22.9 cm

La manda [The offering] 1946
gelatin silver print
22.9 x 17.8 cm

Culpas ajenas [Faults of others] 1948
gelatin silver print
17.8 x 22.9 cm

Tiburoneros [Shark hunters] 1950
gelatin silver print
17.8 x 24.1 cm

Manuel Alvarez Bravo
Colchón (negative) No. 1
[Mattress (negative) No. 1] 1927
platinum print
20.3 x 25.4 cm

Obstáculos (No. 5) [Obstacles (No. 5)] 1929
platinum print
20.3 x 25.4 cm

Pan nuestro (No. 3) [Our daily bread (No.
3)] 1929
platinum print
20.3 x 25.4 cm

Organo cacti (No. 36) [Organ cacti (No. 36)]
1929–1930
platinum print
20.3 x 25.4 cm

El instrumental [The instruments] 1931
gelatin silver print
20.3 x 25.4 cm

Escalera grande (No. 20) [Large ladder
(No. 20)] 1932
platinum print
20.3 x 25.4 cm

Lavanderas sobrentendidas (No. 26)
[Implied laundresses (No. 26)] 1932
platinum print
20.3 x 25.4 cm

El espejo negro (No. 29) [The black mirror
(No. 29)] 1947
platinum print
20.3 x 25.4 cm

El pájaro canta mientras la ramā cruje (No. 16)
[The bird sings while the branch rustles
(No. 16)] 1960
platinum print
20.3 x 25.4 cm

Novios de Usila (No. 22) [The bridal couple
from Usila (No. 22)] 1964
platinum print
20.3 x 25.4 cm

Fruta prohibida (No. 2) [Forbidden fruit
(No. 2)] 1976
platinum print
20.3 x 25.4 cm

En un pequeño espacio (No. 48) [In a small
space (No. 48)] 1995
platinum print
20.3 x 25.4 cm

Leonora Carrington
Autoportrait à l'Auberge du Cheval de l'Aube
[Self-portrait at the Dawn Horse Inn]
1936–1937
oil on canvas
63.0 x 80.0 cm
private collection
© Leonora Carrington, 1936–37/ARS.
Licensed by VISCOPY, Sydney 2001

Los poderes de Madame Phoenecia
[The powers of Madame Phoenecia] 1974
mixed media on silk
42.5 x 44.5 cm
© Leonora Carrington, 1974/ARS.
Licensed by VISCOPY, Sydney 2001

Rafael Cidoncha
Retrato de la Señora Natasha Gelman
[Portrait of Mrs Natasha Gelman] 1996
oil on canvas
92.0 x 73.0 cm

Miguel Covarrubias
Retrato de Diego Rivera [Portrait of Diego
Rivera] *c.*1920
ink and watercolour on paper
29.0 x 21.0 cm

Jesús Reyes Ferreira
El adiós [The farewell] not dated
tempera on paper
75.5 x 49.5 cm

El florero [Flower vase] not dated
tempera on paper
74.0 x 48.5 cm

Sin título [Untitled] not dated
tempera on paper
75.0 x 48.5 cm

Gunther Gerzso
Los cuatro elementos [The four elements]
1953
oil on canvas
100.0 x 65.0 cm

El gato de la Calle Londres I [The cat from
London Street I] 1954
oil on canvas
64.0 x 80.0 cm

Paisaje arcaico [Archaic landscape] 1956
oil on composition board
80.0 x 53.0 cm

Retrato del Señor Jacques Gelman
[Portrait of Mr Jacques Gelman] 1957
oil on canvas
72.0 x 60.0 cm

Personaje en rojo y azul [Figure in red
and blue] 1964
oil on canvas
100.0 x 73.0 cm

María Izquierdo
Los caballos [Horses] 1938
watercolour on paper
21.0 x 28.0 cm

Escena de circo [Circus scene] 1940
gouache on paper
42.0 x 54.0 cm

Frida Kahlo
© 2001 INBA and Banco de México Diego
Rivera & Frida Kahlo Museums Trust. Av.
Cinco de Mayo No. 2, Col. Centro, Del.
Cuauhtémoc 06059, México, D.F
for all Frida Kahlo works

Autorretrato con collar
[Self-portrait with necklace] 1933
oil on metal
35.0 x 29.0 cm

Dibujo de Nacho Aguirre [Drawing of
Nacho Aguirre] (recto) 1935
pencil and sepia ink on paper
22.3 x 21.7
Dibujo de Ojos [Drawing of eyes] (verso)

Autorretrato con cama
[Self-portrait with bed] 1937
oil on metal
40.0 x 30.0 cm

Retrato de Diego Rivera
[Portrait of Diego Rivera] 1937
oil on composition board
53.0 x 39.0 cm

Autorretrato con trenza
[Self-portrait with braid] 1941
oil on canvas
51.0 x 38.5 cm

Autorretrato con vestido rojo y dorado
[Self-portrait with red and gold dress]
1941
oil on canvas
39.0 x 27.5 cm

Autorretrato con monos
[Self-portrait with monkeys] 1943
oil on canvas
81.5 x 63.0 cm

Diego en mi pensamiento
[Diego on my mind] 1943
oil on composition board
76.0 x 61.0 cm

La novia que se espanta de ver la vida abierta
[The bride who became frightened when
she saw life opened] 1943
oil on canvas
63.0 x 81.5 cm

Retrato de la Señora Natasha Gelman
[Portrait of Mrs Natasha Gelman] 1943
oil on composition board
30.0 x 23.0 cm

*Dibujo con un pie a la izquierda y senos a la
derecha* [Drawing with a foot on the left
and breasts on the right] 1946
colour pencil and graphite on paper
21.3 x 27.0 cm

Karma 1946
Mexico sepia ink on paper
21.6 x 27 cm

Karma I 1946
sepia ink on paper
18.0 x 27.0 cm

*El abrazo de amor del universo, la tierra
(México) Diego, yo y el Señor Xolotl*
[The love embrace of the universe,
the earth (Mexico) Diego, me and Señor
Xolotl] 1949
oil on composition board
70.0 x 60.5 cm

Agustín Lazo
Fusilamiento [Execution by firing squad]
c.1930–1932
gouache and ink on paper
24.6 x 33 cm

Juegos peligrosos [Dangerous games]
c.1930–1932
gouache and ink on paper
35.0 x 23.5 cm

Robo al banco [Bank robbery] c.1930–1932
gouache and ink on paper
27.0 x 36.5 cm

Carlos Mérida
Fiesta de pájaros [Festival of the birds]
1959
painted board
50.0 x 40.0 cm
© Carlos Merida, 1959/SOMAAP.
Licensed by VISCOPY, Sydney 2001

El mensaje [The message] 1960
painted board
71.0 x 88.0 cm
© Carlos Merida, 1960/SOMAAP.
Licensed by VISCOPY, Sydney 2001

Variación de un viejo tema
[Variations on an old theme] 1960
oil on canvas
89.0 x 69.5 cm
© Carlos Merida, 1960/SOMAAP.
Licensed by VISCOPY, Sydney 2001

Cinco paneles [Five panels] 1963
(a) watercolour and pencil on cardboard;
(b) gouache, watercolour and pencil on
cardboard; (c) gouache, watercolour and
pencil on cardboard; (d) gouache,
watercolour and pencil on cardboard;
(e) gouache, watercolour and pencil on
cardboard
130.0 x 25.0 cm (each panel unframed)
© Carlos Merida, 1963/SOMAAP.
Licensed by VISCOPY, Sydney 2001

Roberto Montenegro
Amanecer [Dawn] 1950
oil on canvas
80.3 x 80.3 cm

José Clemente Orozco
© Clemente V. Orozco
for all Josè Clemente Orozco works

Desnudo femenino [Female nude]
not dated
ink and charcoal on paper
48.0 x 64.0 cm

Estudios de figura (Estudio para los
murales de la Escuela Nacional
Preparatoria [Figure studies (Studio
drawing for the murals of the National
Preparatory School)] *c.*1926
charcoal on kraft paper
61.5 x 96.5 cm

Estudios de figura (Estudio para los
murales de la escuela Nacional
Preparatoria) [Figure studies (Studio
drawing for the murals of the National
Preparatory School)] *c.*1926
charcoal on kraft paper
95.0 x 71.0 cm

Autorretrato [Self-portrait] 1932
watercolour and gouache on paper
37.0 x 30.0 cm

Sin título (Salón México) [Untitled (Salon
Mexico)] 1940
gouache on paper
49.0 x 67.0 cm

Pintura [Painting] 1942
oil on paper
37.0 x 25.0 cm

Untitled [Liberty] 1945
pencil and ink on paper
37.5 x 28 cm

Carlos Orozco Romero
Danzantes [Dancers] not dated
pencil and watercolour on paper
48.0 x 59.0 cm

Entrada al infinito [Entrance to infinity]
1936
oil on canvas
75.0 x 55.0 cm

La novia [The bride] 1939
oil on canvas
41.0 x 31.0 cm

Protesta [Protest] 1939
oil, gouache and pencil on canvas
39.0 x 32.0 cm

Diego Rivera
© 2001 INBA and Banco de México Diego
Rivera & Frida Kahlo Museums Trust. Av.
Cinco de Mayo No. 2, Col. Centro, Del.
Cuauhtémoc 06059, México, D.F
for all Diego Rivera works

Sin título [Untitled], not dated
pencil on paper
31.0 x 23.0 cm

Ultima hora [The last hour] 1915
oil on canvas
92.0 x 73 .0 cm

Paisaje con cactus [Landscape with cactus]
1931
oil on canvas
125.5 x 150 cm

Modesta [Modesta] 1937
oil on canvas
80.0 x 59.0 cm

El curandero [The healer] 1943
gouache on paper
47.0 x 61.0 cm

Girasoles [Sunflowers] 1943
oil on wood
90.0 x 130.0 cm

Niña con guantes [Girl with gloves] 1943
watercolour on paper
73.0 x 53.0 cm

Retrato de la Señora Natasha Gelman
[Portrait of Mrs Natasha Gelman] 1943
oil on canvas
115.0 x 153.0 cm

Vendedora de alcatraces [Calla lily vendor]
1943
oil on composition board
150.0 x 120.0 cm

David Alfaro Siqueiros
Siqueiros por Siqueiros [Siqueiros by
Siqueiros] 1930
oil on canvas
99.0 x 79.0 cm

Cabeza de mujer [Head of a woman] 1939
oil on canvas
54.5 x 43.0 cm

Mujer con rebozo [Woman with shawl] 1949
pyroxilyn on composition board
119.5 x 97.0 cm

Retrato de la Señora Natasha Gelman
[Portrait of Mrs Natasha Gelman] 1950
pyroxilyn on composition board
120.0 x 100.0 cm

Juan Soriano
Niña con naturaleza muerta
[Girl with a still life] 1939
oil on canvas
81.3 x 65.2 cm

Naturaleza muerta con madrepora
[Still life with brain coral] 1944
oil on composition board
60.3 x 51.9 cm

Rufino Tamayo
Rooftops 1925
oil on canvas
99.7 x 99.7 cm
© Inheritors of the artist in support of
Fundación Olga y Rufino Tamayo, A.C.

Retrato de Cantinflas [Portrait of
Cantinflas] 1948
oil on canvas
100.0 x 80.5 cm
© Inheritors of the artist in support of
Fundación Olga y Rufino Tamayo, A.C.

Retrato de la Señora Natasha Gelman
[Portrait of Mrs Natasha Gelman] 1948
oil and charcoal on composition board
120.0 x 91.0 cm
© Inheritors of the artist in support of
Fundación Olga y Rufino Tamayo, A.C.

Emilio Baz Viaud
Retrato de Nazario Chimez Barket
[Portrait of Nazario Chimez Barket] 1952
watercolour and dry brush on cardboard
74.0 x 53.0 cm

Angel Zárraga
Sin título [Untitled] *c.*1915–17
oil on canvas
46.5 x 33.5 cm

Retrato del Señor Jacques Gelman
[Portrait of Mr Jacques Gelman] 1945
oil on canvas
130.5 x 110.5 cm

Retrato de la Señora Natasha Gelman
[Portrait of Mrs Natasha Gelman
(unfinished)] *c.*1946
oil on canvas
109.0 x 109.0 cm

ARTISTS' BIOGRAPHIES

LOLA ALVAREZ BRAVO

Lola Alvarez Bravo was born in 1905 at Lagos de Moreno in Mexico. In the 1920s she began taking photographs with her husband, the Mexican photographer Manuel Alvarez Bravo. She did not come into her own as an artist, however, until her separation from Manuel in 1934, when she moved into the house of Maria Izquierdo and began working in a number of photographic genres, including male and female nudes, still-lifes, landscapes, photomontage and portraits of her artist friends. She was close to Frida Kahlo and hosted Kahlo's first solo Mexican exhibition at her own gallery, the Galeria de Arte Mexicano, in 1953. Although Bravo's work tends towards a documentary depiction of street life in Mexico, through her unusual formal compositions and choice of subject, she elevates the images of people's everyday lives into a veritable poetry of the real. She had a retrospective at the Centro Cultural/Arte Contemporaneo in Mexico City in 1992. Bravo died in 1993.

MANUEL ALVAREZ BRAVO

Born in 1902 in Mexico City, Manuel Alvarez Bravo initially studied painting and music at the Academia Nacional de Bellas Artes in Mexico City. In the early 1920s, he became interested in photography, and bought his first camera in 1923. Through his friendship with Tina Modotti he met Diego Rivera and Frances Toor, photographing the work of the Mexican mural painters for Toor's book *Mexican Folkways*. He taught at the San Carlos Academy under the directorship of Rivera in 1929 and 1930. During the 1930s he was acquainted with Mexico's premier painters and writers and formed friendships with international photographers Paul Strand and Henri Cartier-Bresson. In 1938 he met the French surrealist writer André Breton, who included him in surrealist exhibitions and journals. His images of life in Mexico speak to contemporary political or social problems and capture something of the mystery lurking in the everyday. In recent years there have been retrospective exhibitions in Paris (1980), Madrid (1985) and New York (1997).

LEONORA CARRINGTON

Born into an upper middle-class English family in 1917, Leonora Carrington was a rebellious child. She was expelled from two schools and deemed 'uneducable' before, in 1936, she enrolled at the Amedée Ozenfant Academy, London. There she was introduced to the surrealist movement and, the following year, met Max Ernst. Her relationship with Ernst ended when he was interned as an enemy alien in France on the outbreak of World War II. Carrington subsequently suffered a nervous breakdown and was placed by her family in a psychiatric hospital in Spain. She was later taken to Lisbon but managed to escape her guards and take refuge in the Mexican embassy, where she was offered protection by a Mexican diplomat, whom she later married. She then travelled, by way of New York, to Mexico, where she and Ernst were reunited in 1940 – although, by this time, their romantic involvement was over. Carrington settled in Mexico in 1942, where she remained until 1985, painting symbolic landscapes and portraits inspired by mystical traditions (Assyrian, Egyptian and Christian) and the magical, transformative aspects of Mexican culture. She is also an accomplished writer in the surrealist tradition. She currently resides in the United States.

RAFAEL CIDONCHA

Rafael Cidoncha's works are principally portraits and interiors. His 1996 portrait of Natasha Gelman, the last portrait painted in her lifetime, shows the collector in her home in Cuernavaca. On the table before her is the catalogue for the Giannanda Foundation's exhibition showcasing the Gelman's European collection: on the wall behind her is the Frida Kahlo painting *Self-portrait with monkeys*. Cidoncha, who was born in Vigo, Spain, in 1952, recently completed a commissioned portrait of King Juan Carlos of Spain for the city of Seville. He has exhibitied in Madrid, New York, Brussels and Frankfurt.

MIGUEL COVARRUBIAS

Basing his artworks on the nightlife he observed in the theatres and cafes of Mexico City (where he was born in 1904), Miguel Covarrubias published his first drawings and caricatures in Mexican newspapers and magazines. Between 1923 (when he first visited New York) and 1936, he was the official caricaturist for *Vanity Fair*. Diego Rivera praised Covarrubias's 'caustic but implacably good-humoured drawings which, fortunately for his personal safety, people have been misled into calling caricatures'. Covarrubias travelled extensively around the world on a Guggenheim scholarship. He produced numerous books of caricatures and drawings as well as ethnographic studies, most importantly *Indian Art of Mexico and Central America*, which was published in New York in 1957, the year of his death.

JESUS REYES FERREIRA

Jesús 'Chucho' Reyes Ferreira did not consider himself a professional artist. He was born in 1882, in Guadalajara. He began his career as a collector of colonial and folk art, with a makeshift 'antique shop' in his home. Ferreira's first pictures were 'smeared' works on paper, which he used in his shop. After moving to Mexico City in the 1930s, he set up a studio and developed a repertoire of subjects, including depictions of circus characters, animals, Christ figures and skulls. He developed a unique range of colour gouaches, and occasionally applied gold and silver powder to create decorative effects. His work is characterised by a freshness and sensuality both in its technique and subject matter. He died in Mexico City in 1977.

GUNTHER GERZSO

Of Hungarian and German descent, Gunther Gerzso was born in Mexico City in 1915. After four years in Europe, he returned to Mexico in 1931, before moving on to the United States in 1935, where he found work as a stage designer. In 1940 he began painting seriously and returned to Mexico the next year, where he supported himself designing film sets. During the next two decades he was designer for nearly 250 films, working with such directors as Luis Buñuel and John Ford. After a period in which he was influenced by the surrealists – many of whom he had met during their exile in Mexico – Gerzso began exploring pre-Columbian motifs. His works from the 1960s onwards integrate traditional motifs with internationalist abstraction. Octavio Paz has described Gerzso's work as 'a system of allusions rather than a system of forms'. He lives in Mexico.

MARIA IZQUIERDO

Raised in the provincial town of San Juan de los Lagos, where she was born in 1902, Izquierdo entered an arranged marriage aged fourteen. After moving with her husband and three children to Mexico City in 1923, she separated from him and began painting. After a brief period of organised study – during which her work was admired by Diego Rivera – she shared a studio and lived with Rufino Tamayo. In 1930 her works were included in an exhibition of Mexican art at the Metropolitan Museum of Art in New York. In 1935 she organised an exhibition of revolutionary posters by women artists, and the following year her work was admired by the visiting French writer Antonin Artaud, who wrote enthusiastically about her paintings and arranged for them to be shown in Paris. Like Kahlo, Izquierdo basked in the Mexican cultural revival from the 1920s onwards, frequently wearing traditional clothing and jewellery. She continued painting still-lifes and surrealistic scenes, despite an embolism which, in 1950, left her paralysed for a time. Since Izquierdo's death in 1955, her reputation has continued to grow. An important painting was included in the exhibition *Beyond Belief: Modern Art and the Religious Imagination*, at the National Gallery of Victoria, Melbourne, in 1998.

FRIDA KAHLO

Born in 1907 (not 1910 as she often claimed), Frida Kahlo was the daughter of a German photographer – her father – and a Mexican mother. At the age of eighteen she was seriously injured in a road accident and was partially crippled for the rest of her life. She married Diego Rivera in 1929, and their traumatic relationship was to be both her inspiration and her scourge. She painted many self-portraits, as well as portraits, still-lifes and surrealistic scenes. She died, aged forty-seven, in 1954. As well as becoming a cult figure internationally, Frida Kahlo has achieved almost saint-like status in her native country.

AGUSTIN LAZO

Born in 1900, Agustín Lazo trained as a theatre designer in Paris during the 1920s, at which time he became interested in surrealist art, particularly the work of Giorgio de Chirico. He is the only Mexican artist to have frequented the Parisian surrealist circle during its heyday. After a brief return to Mexico in 1927 to paint a mural, he travelled through France, Belgium, Germany and Italy. Lazo belonged to the 'contemporaneos' group, which opposed the political and nationalistic objectives of the muralists, emphasising instead a less rhetorical approach. He spent much of the 1930s and 1940s working as a set designer. His work was included in the surrealist exhibition at the Galeria de Arte

Mexicano in 1940. In 1971, the year of his death, a retrospective was held at the Museo de Arte Moderno, Mexico City.

CARLOS MERIDA

A native of Guatemala, where he was born in 1891, Carlos Mérida studied painting and music before travelling to Europe in 1910, where his teachers included Kees van Dongen and Amedeo Modigliani. Returning to Guatemala in 1914 he was involved in the formation of an artistic pro-Indian movement. After two years in New York, Mérida took up permanent residence in Mexico in 1919, and the following year exhibited his Modernist-inclined compositions. In the 1920s he was involved in the muralist movement and worked for a time as Rivera's assistant. A notable critic and art historian, he wrote a series of books on the muralists. By the 1930s he was exploring not only the abstract and surrealist art of Europe but also pre-Columbian forms. In the 1950s he studied Venetian mosaic techniques in Italy, then returned to Mexico to produce large murals and reliefs on public buildings (including a kindergarten). He died in Mexico City in 1984.

ROBERTO MONTENEGRO

Born in Guadalajara, 1887, Roberto Montenegro studied architecture in Mexico City before enrolling at the Escuela Nacional de Arte, where he met Diego Rivera in 1904. The following year, he travelled to France and Spain. Like Rivera, he spent much of the revolutionary period abroad, returning in 1920 to paint his first murals. In 1930 he met Sergej Eisenstein and accompanied him during the filming of *Que Viva México*. In 1934 he became director of the Museo de Artes Populares de Bellas Artes. Montenegro died in 1968 during a journey to Pátzcuaro west of Mexico City in Michoacán .

JOSE CLEMENTE OROZCO

José Clemente Orozco was born in Jalisco in 1883 and received an agricultural education before studying at the Academia de San Carlos, 1908–1914. During the revolution, he worked as a cartoonist for various radical publications. Shortly after his first exhibition in 1916, he travelled to the United States where he worked as a sign painter. On his return to Mexico in 1920, he was enlisted to work alongside Rivera and Siqueiros to establish a national school of mural painting. An internationalist, his concerns as a painter went beyond the nationalism of Rivera. His paintings and murals show the influence of expressionism – particularly the work of Franz Marc and Georges Rouault. They assert not only the primal power embodied in the human figure but also humanity's need to recognise and escape the

entrapments of history and organised religion. Orozco devoted himself completely to the ideals of socialism and public art, renouncing the commercial art world and destroying all his early canvases. He died in Mexico City in 1949.

CARLOS OROZCO ROMERO

Born in Guadalajara, 1896, Carlos Orozco Romero joined the avant-garde group called 'Centro Bohemio' in 1913 and moved to Mexico City, where he worked as an illustrator and cartoonist. He travelled to France and Spain during the early 1920s before returning to his hometown where he produced graphic prints and ran a printmaking shop at the Jalisco Preparatory School. Between 1928 and 1932 he and Carlos Mérida co-directed the Galería de Bellas Artes. In 1946 he was a founder member of 'La Esmeralda', the National School of Painting and Sculpture, Mexico City. He continued to travel extensively and participated in the 1958 Venice Biennale. He died in 1984.

DIEGO RIVERA

'An extraordinary painter, a lighthouse of vitality,' was the way that Robert Hughes described him. Diego Rivera was born in Guanajuato in 1886. When he was ten he enrolled at the Academia de San Carlos but left when he was sixteen, having rejected the photographic realism the institution was encouraging. Five years later he was awarded a grant to study in Spain. Apart from a brief return to Mexico, he was based in Europe from 1907 until 1921. He painted his first murals in 1922 and was co-founder of the Union of Revolutionary Painters, Sculptors and Graphic Artists. He married Frida Kahlo in 1928 and they moved to the United States in 1930, travelling and working extensively there until 1934. Considered, during his lifetime, the foremost living Mexican artist, Rivera was hugely prolific, creating many murals as well as easel paintings. 'Few twentieth century artists have been as popular in their own societies,' Hughes wrote. 'None is more relevant to the debate over "indigenous" or "national" art language as against "international style".' Rivera died in Mexico City in 1957.

DAVID ALFARO SIQUEIROS

Born in Chihuahua in 1896, Siqueiros joined the Constitutionalist Army during the Mexican revolution and, while travelling in Europe as a military attaché in 1917, met Diego Rivera. After the revolution he received a travel grant which enabled him to study for three years in Europe. On his return to Mexico in 1922 he joined the muralist movement. He urged Mexican artists to follow his example and spurn 'so-called easel painting and every kind of art favoured by the ultra-intellectual circles,

because it is aristocratic, and promote monumental art in all its forms, because it is public property'. Exiled from Mexico in 1932 on account of his politics, he worked in the United States, where he started painting with an airbrush and exploring other new technologies. Deported from the United States the following year, Siqueiros travelled to Uruguay and Argentina. By 1936 he was back in New York, where he established the Siqueiros Experimental Workshop – 'a laboratory of modern techniques in art'. After two years in the Spanish Republican Army, he returned to Mexico in 1940, only to have to flee the country when he was implicated in an attempted assassination of Leon Trotsky. Prolific periods of work during the 1950s and 1960s were interrupted by a four-year stint in jail for political misdemeanours. Siqueiros received the National Prize from the Mexican Government in 1966. Important retrospectives were held in Mexico in 1967 and in Kobe, Japan, in 1972. He died in Mexico City in 1974.

JUAN SORIANO

Born in Guadalajara, Jalisco, in 1920, Juan Soriano had his first exhibition at the age of fourteen. The youngest member of the 'Mexican School' which emerged in the 1930s, he came under the influence of Roberto Montenegro and Jesús Reyes Ferreira. He went on to work as a printmaker, sculptor, designer and painter. With Leonora Carrington, Octavio Paz and Juan José Arreola, he was a member of 'Poesía en voz alta', the group responsible for introducing the Theatre of the Absurd into Mexico. Soriano has been based intermittently in Rome and Paris, exhibiting in those centres as well as in Mexico and the United States.

RUFINO TAMAYO

Born in Oaxaca in 1899, Tamayo was orphaned and taken as a child to live in Mexico City with an aunt who was a fruit and vegetable wholesaler. He attended the Academia de San Carlos, in Mexico City, from 1917 until 1921, when he became Head of the Department of Ethnographic Drawings at the National Museum of Anthropology. He shared a studio with María Izquierdo from 1929 until 1934, during which time both artists developed into maturity. Tamayo's modernist sensibility ran counter to the prevailing tone of Mexican Muralism – a fact which may underlie the artist's decision to live much of his life abroad. He spent extensive periods in Europe and the United States, where he established the Tamayo Workshop at the Art School of the Brooklyn Museum in 1946. During his life he amassed a great collection of pre-Columbian art which, in 1974, he donated to the Mexican people. Tamayo died in Mexico City in 1991.

EMILIO BAZ VIAUD

Far from being a prolific artist, Emilio Baz Viaud's entire output up until 1984 is thought to amount to just fifty paintings. Born in 1918, he spent four years studying architecture, during which time his interest in painting was encouraged by the artist Manuel Rodriguez Lozano. In 1950 Baz Viaud lived in San Miguel de Allende, where he and a friend established the Baz-Fischer Gallery. Aged forty he entered the Benedictine monastery of Santa María de la Resurrección, where he became interested in psychoanalysis. He subsequently returned to painting, working meticulously in the trompe-l'oeil style up until the 1970s, when he experimented with abstraction. He was awarded a gold medal for artistic achievement by the University of Guanajuato. Baz Viaud died in 1991.

ANGEL ZARRAGA

Born in the City of Durango in 1886, Zárraga studied at the Academy of San Carlos in Mexico City before leaving for Paris in 1904. In Europe he was particularly impressed by nineteenth century French Classicism and Spanish art. At the 1911 Salon d'Automne in Paris two symbolist works by Zárraga were greatly acclaimed, establishing his reputation in both France and Mexico. In 1919, he married the notable Russian sportswoman Jeanette Ivanof (and went on to paint many scenes of sportsmen and women). Turning down a large mural commission in 1921, Zárraga did not return to Mexico until 1942. Like Rivera, he was initially influenced by Cubism but returned to a realist style, painting many religious subjects. In Mexico, his work has at times been criticised for being upper class and Eurocentric. Zárraga wrote of the physical and spiritual aspects of Mexican life: 'The physical is manifest at the big sports stadiums, the spiritual at the temples. In each one of these spaces, Man finds a mitigation to his anguishes.' He died in Mexico City in 1946.

ENDNOTES

'PEOPLE ARE VYING FOR SHREDS OF HER GARMENTS'

1. *The Art Newspaper*, January 2001, p. 45. All prices quoted are in Australian dollars.

2. See <http://members.aol.com/fridanet/kahlo.htm>. Lucy Potts found the reference.

3. Quoted in Margaret A. Lindauer, *Devouring Frida: The art history and popular celebrity of Frida Kahlo*, University Press of New England, Hanover, 1999, p. 3.

4. For a summary of this see Lindauer, *Devouring Frida*, pp. 60-1.

5. See, for example, Andrea Mantegna, *St Sebastian* (*c*.1459), Kunsthistorisches Museum, Vienna.

6. Hamlet (III.i.64–8).

7. Linda Nochlin, 'Why have there been no great women artists?' in *Women, Art, and Power and Other Essays*, Thames & Hudson, London, 1989, pp. 145-78

8. Quoted in Raquel Tibol, 'Frida Kahlo', *Art of the Fantastic: Latin America 1920–1987*, exhibition catalogue, Indianapolis Museum, Indianapolis, 1987, p. 216.

JACQUES AND NATASHA

1. Pierre Schneider in *The art of collecting*, p. 19.

2. 'Manifesto of the Union of Mexican Workers, Technicians Painters and Sculptors', *El Machete*, 1923, Mexico City. Reprinted in Dawn Ades, *Art in Latin America: in the modern era, 1820–1980*, Yale University Press, New Haven, 1989, pp. 323-4.

3. Octavio Paz, 'Will for form', in *Mexico: Splendors of thirty centuries*, exhibition catalogue, Metropolitan Museum of Art, New York, 1990, p. 36.

4. Quoted in Sylvia Navarrete, 'The Gelman collection: Figurative painting, Surrealism and abstract art', in *Frida Kahlo, Diego Rivera, and Twentieth Century Mexican Art*, exhibition catalogue, Museum of Contemporary Art, San Diego, 2000, p. 50.

MY MOTHER, MYSELF AND THE UNIVERSE...

1. André Breton, 'Frida Kahlo de Rivera', in *Surrealism and Painting*, MacDonald and Co., London, 1972, p. 144.

2. Breton, 'Frida Kahlo de Rivera', p. 144. Haydon Herrera, *Frida: A biography of Frida Kahlo*, Harper & Rowe, New York, 1983, p. 254.

3. André Breton, *Manifeste du Surréalisme*, Editions du Sagittaire, Paris, 1924.
 Quoted in Sarah Lowe, *Frida Kahlo*, Universe, New York, 1991, p. 78.

4. Sarah M. Lowe, *The Diary of Frida Kahlo; An intimate self-portrait*, Harry N. Abrams, New York, 1995, p. 235.

5. Quoted in 'Diego Rivera, Frida Kahlo and Mexican art' in *Frida Kahlo and Tina Modotti*, exhibition catalogue, Whitechapel Art Gallery, London, 1982, p. 37.

6. Quoted in *Mexico: Splendour of thirty centuries*, exhibition catalogue, The Metropolitan Museum of Art, New York, 1990, p. 693.

7. Quoted in Raquel Tibol, *Frida Kahlo: An open life*, University of New Mexico Press, Albuquerque, 1993, p. 139.

8. See the discussion of this painting in Lindauer, *Devouring Frida*, pp. 51-2.

9. See Lowe, *Frida Kahlo*, p. 51.

10. See *Frida Kahlo and Tina Modotti*, p. 18.

INDEX

Spanish surnames generally consist of three parts: the personal name, followed by the father's name, and then the mother's name. People are generally known by the second and third names together. In this index artists are listed under the name by which they are generally known in the art world.

Throughout the index, FK refers to Frida Kahlo and DR to Diego Rivera.

Numbers in *italics* indicate pages with illustrations.

95